Praise for Adam Leipzig

P9-DEP-684

INSIDE TRACK
FOR INDEPENDENT FILMMAKERS
GET YOUR MOVIE MADE, GET YOUR MOVIE SEEN

"Adam Leipzig writes about simple truths in strong, easy-to-read prose. It's a great, fast read and reminds you how easy and difficult it is to make good and bad movies. *Inside Track* is like a divining rod as it points the way for filmmakers and readers through the labyrinth of this tricky medium. Adam Leipzig loves films and filmmakers—it's obvious in his previous writing and it's doubly obvious in this wonderful handbook."
— Neil LaBute, director and writer, *In the Company of Men, Nurse Betty, The Wicker Man, Death at a Funeral, Some Velvet Morning*

"'The way to get your movie made is to *think like your buyer.*' Adam Leipzig's *Inside Track* is indeed that, a deceptively simple, well-laid-out path for filmmakers to follow step-by-step through the blind, thorny thicket of independent filmmaking. Precise, concise, and jolly, even a page-turner, Adam's book is clear and encouraging, never snarky or cynical."
— Lynne Littman, Academy Award–winning director, *Testament, Number Our Days*

"Adam Leipzig's *Inside Track for Independent Filmmakers* is vital, essential reading for anyone planning, hoping, or dreaming to make a movie that gets seen."
— Richard Abramowitz, independent distribution and marketing guru, whose recent projects include *Particle Fever, Exit Through the Gift Shop, Flowers of War, Senna, The Way*

"The straightforward, no-nonsense guide you've been waiting for! Adam Leipzig shares wisdom, tough love, and insider

information that will help you get your movie made and sold. Every independent filmmaker should read it!"

—Cherien Dabis, writer/director, *Amreeka, May in the Summer*

"Adam Leipzig's book speaks with the intimacy of experience and a forensic intensity that makes it a must-read for every aspiring filmmaker."

—Nigel Sinclair, producer, *A Walk Among the Tombstones, The Woman in Black, Undefeated, Let Me In,* and many more

"Adam Leipzig's book is a tremendous guide to navigating the waters that are Hollywood. Filled with wisdom and insight, this book is a must-read for anyone even considering making a movie!"

—Ruth Vitale, executive director, CreativeFuture; former president, Paramount Classics, whose projects have included *Hustle and Flow, Dirty Dancing, Mad Hot Ballroom, Paris, je t'aime, The Proposition, You Can Count on Me,* and *The Virgin Suicides*

"Adam Leipzig's *Inside Track for Independent Filmmakers* is a must-read if you are serious about getting financing or distribution for your movie. It's rare for someone with Adam's prestigious track record to share so much information. This book is to the point, step-by-step, and tells you exactly what to do."

—Howard Cohen, co-president, Roadside Attractions, distributor of *Winter's Bone, Margin Call, Biutiful, Arbitrage, Dear White People,* and many more indie films

"This very informative book takes you inside today's independent film production world. In a straightforward and easy-to-understand style, it provides the specifics you need to know to get your movie off the ground and in front of audiences. One of the best how-to books on independent film I've read in quite a while."

—Joe Pichirallo, chair, Undergraduate Film & Television Program, NYU Tisch School of the Arts, Kanbar Institute of Film and Television

INSIDE TRACK™

FOR INDEPENDENT FILMMAKERS

GET YOUR MOVIE MADE, GET YOUR MOVIE SEEN

ADAM LEIPZIG

Bedford/St. Martin's

A Macmillan Education Imprint

Boston • New York

For Bedford/St. Martin's
Vice President, Editorial, Macmillan Higher Education Humanities: Edwin Hill
Publisher for Communication: Erika Gutierrez
Senior Editor for the Inside Track series: Adam Leipzig
Associate Editor: Alexis Smith
Senior Production Editor: Peter Jacoby
Production Manager: Joe Ford
Marketing Manager: Thomas Digiano
Director of Rights and Permissions: Hilary Newman
Senior Art Director: Anna Palchik
Text Design: Glen Edelstein
Cover Design: Adil Dara
Cover Photos: top left, Hassel Sinar/Shutterstock; top right, StockLite/Shutterstock; bottom left, Tatiana Popova/ Shutterstock; bottom middle, Denys Prykhodov/Shutterstock; bottom right, Steve Collender/Shutterstock
Printing and Binding: RR Donnelley and Sons

9 8 7 6 5 4
f e d c b a

For information, write: Bedford/St. Martin's, 75 Arlington Street, Boston, MA 02116 (617-399-4000)

ISBN 978-1-319-01318-9

To creative entrepreneurs everywhere, without whom our world would be incredibly boring.

David A. Buehler, PhD
50 Elliot Street
Dartmouth, MA 02747-1925

ABOUT THE AUTHOR

Photo by Anne Fishbein

Adam Leipzig is the CEO of Entertainment Media Partners, which provides informed guidance for independent media companies, financiers, and producers, and is the publisher of *Cultural Weekly* (http://www.culturalweekly.com/). Adam teaches at Chapman University's Dodge College of Film and Media Arts, in the Executive Education program of UC Berkeley's Haas School of Business, and in UCLA's Professional Producing Program. He has overseen more than 25 movies as a producer, executive, and distributor, including *March of the Penguins*; *Dead Poets Society*; Julie Taymor's first film, *Titus*; Cherien Dabis's first film, *Amreeka*; Byambasuren Davaa and Luigi Falorni's first film, *The Story of the Weeping Camel*; Joe Johnston's first film, *Honey, I Shrunk the Kids*; and Jon Turteltaub's first film, *3 Ninjas*, and he has worked with legendary directors Robert Altman, Peter Yates, and Peter Weir. Adam served as the president of National Geographic Films and senior vice president at Walt Disney Studios, and in each of those positions was responsible for the most profitable film of the year. He is an author of *Filmmaking in Action: Your Guide to the Skills and Craft*, a comprehensive overview of filmmaking techniques and principles for students in college and beyond, available at http://www.macmillanhighered.com/filmmaking. Adam loves to hear from his readers; contact him at Adam@AdamLeipzig.com.

FOREWORD

By Ted Hope

Adam Leipzig is the consummate sharer. For more than a decade, he has committed himself to sharing insider information with creative people—the kind of knowledge you only get when you have been on "the inside" at a big movie studio or distribution company. Adam has done all of that and has been a producer as well. He knows what's what and, just as importantly, what you really need to focus on.

He doesn't tell you how to make your movie in this book. He assumes you already know that, and I assume that if you're a true filmmaker, you never stop learning how. Instead, this book tells you—specifically, point by point, with precise instructions—how to get your movie financed and distributed. It will become your indispensible how-to guide.

There has never been a better time for creative individuals to be truly independent filmmakers and collaborative creators. The barriers to entry are tiny, the cost and labor time of creation and distribution are lower than ever, and new opportunities and methods abound.

For us filmmakers, the world has changed. New possibilities abound. The artistic future of the film industry depends on our willingness to seize the opportunities before us. We cannot approach the creative, production, distribution, or business process in the ways we used to. For those

of us willing to drop the blinders of the past, the time is now.

Until 20 years or so ago, film production generally entailed filmmakers' having to work for someone else because the cost of production was so extreme—you simply weren't able to afford it on your own. Now, the economic barrier to personally producing what you yourself have conceived of has virtually disappeared. What, you might ask, has caused this disappearance? Digital Evolution.

Because of digital distribution platforms, which you will find are discussed throughout *Inside Track for Independent Filmmakers*, the power to create, access, spread, amplify, and appreciate film is available to each and every one of us. If you don't think you already have these powers, think again—because you do. To assume the role of digital distributor for your own film, you will need to break down the false divisions between art and commerce, between you and your audience, and between content and its financing, marketing, and distribution. This book reminds you of your own power, and gives you the tools to assume your rightful place as distributor of your own product.

Discovery, engagement, and the "sell" are all part of our creative mandate: marketing is a Pied Piper, paving the way so we can fully immerse ourselves in the stories we wish to tell. We react not just with our own instincts, but also in accordance with what is happening around us, and what our contemporaries are experiencing, too. The value of our work extends beyond profit, to social, aspirational, and community significance, too.

Distribution, marketing, community—all aspects of sharing—are part of our creation as well. As Adam Leipzig reminds us throughout *Inside Track for Independent Filmmakers*, we craft our stories so others can receive them, in

the contexts of their lives, emotions, and communities, as well as the screens on which they can access our work. For a vibrant independent cinema, what I call Truly Free Film, we need to get our hands dirty and understand how all of this functions and what our roles are. We need better films, and we need to build our audiences and strengthen the communities around them.

Above all, we need transparency—authentic information so we know what's what. The book you're holding in your hands (or on your tablet) is full of transparent, exceptional information you will start using right away. Transparency is not just about data. Transparency is a process, a behavior. By definition, it is an openness to share.

Think about the world you want and the movies you want to make. Think about how you can now actually earn a living doing what you love. Think about how you get there and how you can sustain it. Adam Leipzig reminds us that it is more possible than ever before. I cannot imagine that such thoughts could lead you to any other process than one of sharing with your fellow filmmakers. Sharing leads to engagement—which then prompts action. Wonder why you aren't getting more done? Perhaps because you aren't sharing enough.

If we are transparent with each other, are collaborative, and share our failures and successes openly, we'll be able to abandon the old ways and unearth and embrace the new ways. We'll all be able to make our way to the Inside Track.

So let's get going. Learn. Share. Collaborate. Love your audience. Let them love and engage you back. Truly be free to build the world that you want. We will build it better by all working together.

Ted Hope is the CEO of Fandor, a subscription movie-viewing service and social video-sharing platform (www.fandor.com) hosting many of the greatest films and filmmakers. He has been responsible for more than 70 films, produced through his companies Good Machine and This is that, including The Ice Storm, Eat Drink Man Woman, 21 Grams, In the Bedroom, American Splendor, The Brothers McMullen, *and* Happiness. *He is the author of* Hope for Film *(Soft Skull Press), a film memoir with insights from his directors and productions, as well as a regular blogger at HopeFor-Film.com.*

CONTENTS

IV. Inside Track: Casting 81
Getting the right actors

V. Inside Track: Cost 97
You need to know the numbers

ESSENTIAL RESOURCES

Get More from macmillanhighered.com/insidetrack
and AdamLeipzig.com

PREFACE

As an aspiring filmmaker, you will experience few emotions that rival the joy of stepping onto a film set for your first day of shooting. There will be the thrill of beginnings, the excitement of bringing your vision to life, and an immense sense of achievement.

Yet the first day of shooting is an event experienced by only a small percentage of the people who hope to take that step. For some, their projects simply were not good enough to warrant support. For others, the process of putting together the pieces to make a movie, especially the financial puzzle, was simply too daunting. This book will help you solve these potential problems, by giving you the tools to discover if your movie is worth pursuing in the first place, and how to get the financial resources if it is.

Then, there are many people, far too many, who have the grand excitement of the first day of shooting, the spectacular event of the last day of shooting, and the big finale of finishing their movie—only to discover that no distributor will take it and there is no viable way to get it in front of audiences. This deflating, near-tragic outcome happens to 90% of the movies that are made. However, if you read this book and follow its instructions, it is highly unlikely that you will be one of the unfortunate many.

I have spent the past 25 years of my life in the movie

business, an environment where you will meet the most inventive, collaborative, creative, and generous people in the world—and also people who have the opposite traits. As someone who has sat at many seats of Hollywood's great banquet table—I've been a producer, executive, financier, and distributor, for studio movies and independent films, and for U.S. and international productions—I have had the rare opportunity to understand the many different viewpoints and expectations that must be addressed in order to get a movie made. One of the unique features of this book is that I let you eavesdrop on the conversations that take place after you have left the room. You will learn the Inside Tracks, and they will help you calibrate your approach to financiers and distributors.

What are Inside Tracks, you might ask? They are the quickest, most efficient route to success. When experienced runners are running a race, they move to the innermost ring of the track as they hear the starting pistol fire, because they know that the inside track is a precious few feet shorter that the outside ones. Those few feet can make a world of difference and often account for the difference between the winners and everyone else. In naming this series, I've used the concept of the Inside Track because this book and the ones that follow will give you the insider's edge. Each book will be filled with step-by-step instructions, real-world examples, highly specific directions, and checklists, and will take a no-nonsense approach. Every Inside Track book will be written from the perspective of someone who has run the race many times before and won; as Inside Track authors, we can see you in starting position directly behind us, and we want to make sure you have every advantage as you move forward.

Inside Track for Independent Filmmakers will become

your roadmap to getting your movie made, seen, and distributed. There are 11 Inside Tracks to this roadmap, and each one is composed of several insider tips, for a grand total of 99 essential insider tips. These 99 nuggets of practical, how-to information will tell you what to do, how to approach the toughest challenges unique to the moviemaking business, what to say, whom to meet, and where to go. Among the challenges you will learn to navigate: how to make sure your script reads well (Tip 30), how to make a rational budget (Tip 45), and what to do when you get into a film festival (Tip 65).

This book takes a unique viewpoint in that it does not tell you how to move a camera or shoot a scene. I assume you know how to make a movie or you are well on your way to learning the craft. You will find no filmmaking tips in these pages. This book does not tell you how to make your movie; *it tells you how to get your movie made*. You are about to learn the answers to the two questions producers, filmmakers, and students ask me most: "How do I get my movie made?" and "How do I get my movie seen?"

This pair of questions seeks to unpack the two most puzzling problems facing independent filmmakers today: How do the financial resources come together, and how can filmmakers get meaningful distribution?

Inside Track for Independent Filmmakers is designed to answer these two questions simply and painlessly. Discovering the answers will require a mental shift, though, and for many filmmakers, it will be a groundbreaking one: You have to *think like your buyer*. Here, perhaps, is the most singular difference to this book's approach. By thinking like your buyer, you will discover your buyer's expectations, learn how to fulfill these expectations, and adapt your language into words your buyer can hear. Adopting

such a mental shift typically distinguishes filmmakers who get their movies made from those who don't.

You may believe your buyer is the audience. That's true, but the audience only gets to buy your movie after two other buyers have already put their money down. The first buyer is the financier, the company or private investor that pays for your movie to be made in the first place.

The second buyer is your distributor, the company that actually gets your movie onto theater screens, laptops, television sets, mobile devices, and any other kind of screen where your audience can pay for it. (Even though you may become your own distributor, which you'll learn about in Inside Track XI: Free Range Distribution, if you take this step, you will need to adjust your mind-set to the flinty realities of the digital distribution world.)

Only after these first two buyers, the financier and the distributor, have bought your movie does the audience even get a *chance* to pay to see it.

In this book, you'll learn how to reverse the process many people mistakenly follow. Instead of thinking about the kind of movie *you* want to make, you'll think about the movie you want to make *in the context of what your buyers want to buy.*

Inside Track for Independent Filmmakers is organized into four sections:

THE LANDSCAPE. Here you will get your bearings. "If one does not know the topography, one cannot maneuver an army," wrote Sun Tzu, the sixth-century BC Chinese philosopher and general, in his famous book of military strategy, *The Art of War.* Sun Tzu recognized that if you do not understand the ground on which you walk, it is impossible to find your path.

It's the same with the world of independent film-making—a territory of wonder, glory, mystery, and, occasionally, terror. Before you begin your journey, you need a map that will tell you what to expect in this strange land. The five short essays in this section give you a context for your art and your work. They are meant to provoke you to go out, do your work, and do it well.

GET YOUR MOVIE MADE. What does it take to get a movie made? If you guessed money, you'd be wrong. Of course, money is part of the equation—money to pay the cast and crew, to rent equipment and buy supplies—but you don't get money by asking for money, and in fact, a lack of money is rarely the reason films don't get made.

To get a movie made, the movie has to have *value*. When a film's value is apparent, money races toward it like a river coursing downhill.

The Inside Tracks in this section give you the tools you need to bring massive value to your movie, and with that value, the greatest potential for you to stand on the set one day and shout "Action!" These Inside Tracks are Concept, Comps (short for "Comparatives"), Script, Casting, Cost, and Now You Make Your Movie.

GET YOUR MOVIE SEEN. Once you have made your movie, you want lots of people to see it. To do that, you need to get your film distributed, either by a theatrical distributor, a digital distributor, or a platform you can manage yourself. You will need to be the team leader, driving the process and bringing your audience along with you.

The Inside Tracks in this section include Getting into Festivals When Your Movie's Ready, Selling at Festivals, Selling Everywhere Else for Theatrical Distribution, Selling

for Non-Theatrical Distribution, and Free Range Distribution—the newest form of digital and physical distribution, which allows filmmakers to keep their rights. Taken together, these Inside Tracks will prepare you to distribute on any screen that can show your film.

ESSENTIAL RESOURCES. Here you will find directories of DIY distribution platforms and other filmmaker resources, contact information for sales agents, and other highly curated recommendations so you can gain even more knowledge.

You can use this book in multiple ways.

If you are a filmmaker, please read the whole book, cover to cover, before you do anything else. This will prepare you for what comes next, and what comes next after that. Just as a good film production plan takes post-production into account even before pre-production has begun, the best plan for getting your movie made and seen is derived from being prepared for what's ahead. For example, you will discover that getting distribution is much easier if you have set up your financing in the right way (see Tip 54).

If you are a student, you should also read the entire book. Further, even if your first feature film is still largely a dream, this book will give you practical insights into the inner workings of the movie business. It will help you select what your first movie should be, and provide you with a pragmatic approach to getting it made.

If you are an instructor, you will find that many of the short chapters easily suggest themselves for practical in-class exercises or homework. For example, Inside Track II: Comps can become an energetic, participatory experience in the classroom, as students try to find comps for their

own movie ideas. The financial concepts in Inside Track V: Cost can be adapted into exercises where students practice different financial models for getting films made. The materials filmmakers need to market their movies, enumerated in Inside Track VIII: Selling at Festivals, lend themselves to projects where students can create sample websites and media kits.

No matter what brings you to explore this book, *Inside Track for Independent Filmmakers* will train you to think like a movie executive and distributor, which will give you the Inside Track as an indie filmmaker. That's what you need—because you want to be one of the filmmakers whose films are made *and* seen.

Have fun. Make beautiful movies.

ACKNOWLEDGMENTS

A book is a collaborative exercise, just like a movie. I'm grateful to the independent filmmakers who inspire me every day with their selfless drive and boundless optimism. Thank you to all the readers of the first edition, who generously shared this book with others and offered me numerous suggestions for this new edition. I'm especially grateful to Erika Gutierrez, Alexis Smith, Elise Kaiser, Joe Ford, Thomas Digiano, and Simon Glick, my friends at Bedford/St. Martin's, for their invaluable guidance and for adopting this book (and the Inside Track series) into their fine lineup. Thank you, Jordan Ancel, for telling me I

had to sit down and write this book in the first place. For wise counsel, early reads, and countless good suggestions, thank you, Tod Hardin, James Kaelan, Blessing Yen, Audrey Arkins, Eric Stein, John Forte, Hoyt Hilsman, Nicholas Jarecki, Saundra Saperstein, Garner Simmons, Graham Taylor, Jeremy Walker, and Lori Zimmerman. Thanks to Molly McKellar for fact-checking, Jennifer Greenstein for copyediting, William Rigby for proofreading, and Kirsten Kite for indexing. Deep gratitude to all my friends and colleagues in the movie business who have collaborated with me and taught me over the years, and especially to those who offered generous praise in the opening pages. We also thank the instructors who participated in a review of the Inside Track series concept and offered their valuable insights: Jake Agatucci, *Central Oregon CC*; Frank Barnas, *Valdosta State*; Sara Drabik, *Northern Kentucky Univ.*; Marie Elliot, *Valdosta State*; Erik Johnson, *Univ. of Wisc. – River Falls*; Robert Johnson, *Framingham State*; Madison Lacy, *University of Kansas*; Jamie Litty *UNC – Pembroke*; Phillip Powell, *Valparaiso University*; Shaun Wright, *James Madison University*.

INSIDE TRACK
FOR INDEPENDENT FILMMAKERS
GET YOUR MOVIE MADE, GET YOUR MOVIE SEEN

DON'T DOUBT **YOUR PURPOSE**

As an independent filmmaker, you will encounter the most hard-nosed, brass-knuckled, tough, obnoxious, money-driven, unreasonable, egocentric, foolish people in the world. You will also engage with the most generous, caring, sharing, collaborative, art-driven, quality-minded, creative, entrepreneurial, focused, intelligent, inspiring, and revolutionary people in the world. It will be your job to associate with the latter, in the face of long days, longer nights, and seemingly interminable periods of frustration.

You are here because you know that you must be here; do not doubt the importance of your presence.

People will throw cold water on your face. They'll remind you that indie movies account for less than a quarter of the U.S. box office and there are more than 500 indie films vying for those table scraps. Compare that to the 120 or so studio movies that grab the lion's share. They'll cite statistics about indie films, how many are made, how few are seen, and the crisis crippling independent film distribution.

They will ask: Why should we care if indie movies get made at all?

You'll give them seven reasons.

They're better. If you get rid of indie movies, you'll eliminate half the films nominated for Best Picture. That's

why the Academy went to ten nominations for the top category. When there were only five nominations, indie films drove out studio pictures. With ten nominees, studio films can at least get mentioned—although studio films don't usually win.

They develop talent. New film artists get their start here. Without indie movies, for example, we would not see the work of Christopher Nolan, Darren Aronofsky, Wes Anderson, John Singleton, Sofia Coppola, Robert Rodriguez, Gus Van Sant, Debra Granik, Kathryn Bigelow, David Cronenberg, Brit Marling, David O. Russell, Kevin Smith, Quentin Tarantino, Michael Moore, Steven Soderbergh, Joel and Ethan Coen, Woody Allen, Paul Thomas Anderson, Nicholas Jarecki, Cherien Dabis, Behn Zeitlin, James Marsh, David Guggenheim, Heidi Ewing, Rachel Grady, Amy Berg, Gillian Robespierre, and oh the list goes on . . .

They're authentic. Indie movies let the voices of artists shine through. They aren't manufactured by teams of executives or shaped by note sessions. Yes, indie movies can be widely inconsistent in their quality, but so are studio pictures. And indie movies aren't part of the *entertainment-industrial complex*.

They represent a unique audience. Without indie films, the specialty audience would stop going to theaters entirely. They wouldn't spend their money, instead, on *Transformers 4: Age of Extinction*. The hard-core specialty audience would just stay home.

They are thought leaders. Indie films are made by and for our culture's opinion makers, the people who drive the national discussion on artistic, social, and cultural issues.

They're environmentally sound. No, I don't mean green. I'm referring to biodiversity. Indie films may be only

a small percentage of total annual box office dollars, just as the rain forest represents only a small percentage of the surface area of our planet. Yet indie films represent more than 80% of all artistic output and creativity. Like the rain forest, if indie films collapse and become extinct, the whole ecosystem around them collapses as well. Without indie films, there would be no breeding ground for new talent. No new voices or innovative storytelling approaches (that will later be adopted by studios). No specialty audience that shepherds the mainstream audience by expanding awareness at the margins, an awareness that works its way inward to the mainstream.

They're money. Some businesspeople say, "So what? All that's fine. But it sounds like you want me to distribute indie movies for aesthetic pleasure or the common good, not because they'll make me money." Don't worry, businessperson. We wouldn't ask you to do that. In fact, indie movies make money. You have to look at all the data and put it in context.

In 2013, there were 545 movies released by distribution companies that were not members of the Motion Picture Association of America (MPAA). These are truly indie movies, distributed by non-studio companies. Most of those companies—over 100 of them by my count—are tiny and poorly capitalized. They barely "release" their films except to put them on one or two screens, are not staffed with savvy executives, and hardly have the person-power to market the movies effectively, much less collect money from theaters at the end of the day. The statistics from all these tiny so-called releases get lumped in with the stats of better-released indie fare and drag those numbers down.

Here's the evidence that professionally released indie films do business. In 2013, the Weinstein Company grossed

$492 million with 21 movies. Relativity notched $242 million with 9 movies. Fox Searchlight made $115 million box office gross releasing 11 movies. Focus Features achieved another $101 million with 10 movies, and Film District (which has since taken over Focus) grossed $215 million with just 7 movies. Open Road Films made $148 million with 8 movies. Sony Classics did $70 million with 21 movies. Roadside Attractions notched $45 million on 12 movies. A24 made $28 million with 5 movies. IFC scored $11 million on 38 movies. Radius-TWC made $8 million with 8 movies. Magnolia grossed $7 million with 36 movies. And these numbers do not count home entertainment and video-on-demand revenues, which, in the case of IFC, Magnolia, A24, and others who have adopted a more open-minded business model, often put these companies' films into profits even before they are released onto theater screens.

With proper distribution, indie movies make money, get seen, build artists' careers, shape our culture, and deliver authenticity and quality.

That's why indie movies matter.

That's why you're here.

A SHORT AND RECENT
HISTORY OF INDIE MOVIES
IN AMERICA

If you want to know where you're going, you've got to know where you've been. In this essay, I'll tell you where indie movies have been. This is our Origin Story.

From an artist's point of view, the reason to make an indie film is not to make money. Sure, you want to make some money—enough to let your investors recoup and to pay your rent this month. And, if you really hit the jackpot, enough to finance your next film. That's about it, as far as money expectations go. The reason artists make indie films is to make the movie they want to make, to express something that needs telling. It has never been about getting rich. It has never been about financial greed.

But the tale of American independent films in the past 30 years is a story about artists' aspirations being grounded by greed. About movie companies consuming themselves, wanting something so much that they devour it, and then, by owning, destroy it. About studios trying to hitch a ride on the indie train, then becoming so focused on the bottom line that they blow up the railroad. It's a tale that sets your teeth on edge—for all the movies you didn't get to see, movies that would have represented the singular vision of a small band of committed collaborators; for all the bloated, mean-

ingless movies you ended up seeing instead; and, if you're a filmmaker, for all the movies you didn't get to make.

That's good. The discomfort, the teeth on edge—this is what causes independent movies to exist in the first place, the reason most artists don't sleep at night. Independent movies are filmmakers' natural reaction to being force-fed mainstream movies that don't satisfy audiences' or filmmakers' concerns. In today's media ecology, audiences are like geese whose livers are being turned into foie gras; they're fed a steady diet of entertainment product that only serves to make them delectable to the media and social networking companies so these businesses can take money from their wallets. It's healthy to gag.

Maybe to revive independent films, we have to explain, again, what they are and why they have become so marginalized.

An independent film is one made outside the studio system. That's the business definition. Creatively, it is a film made outside and against the system, any system: the studio system, the political system, the system of conventional storytelling or society or class or ethics or whatever else the filmmaker wants to set right. That's why an independent film more authentically represents its creator's vision—even more important than the fact that there are no suits on the set, no executives from the Black Tower giving notes. The director and his or her crew make their movie, as they want to, and you will like it or you won't.

You say those movies are being made?

If a tree falls in the forest, does it make a sound? For every *Grand Budapest Hotel*, there are hundreds that go unseen.

The crisis of independent filmmaking is really a crisis of viable independent film distribution.

The creative impulse can't be stopped. There are plenty of independent movies being made, especially now, when digital cameras and desktop editing software are so cheap. The numbers: 4,105 films were submitted for the 2015 Sundance Film Festival—that's 4,105 full-length, finished features. Sundance selected 118 feature-length films. And no one will remember the 3,987 movies that didn't get sold or distributed.

Perhaps 100 of the 4,105 finished feature films that were submitted to Sundance this year will eventually get picked up, although most will only get minor online or DVD distribution, and less than a dozen will get a full-scale, nationwide theatrical release. That still leaves those 3,987 movies you won't even be able to find on Netflix or Hulu.

In America, only about 650 movies are released each year, including all the big studio movies, and studio movies play on 95% of the nearly 40,000 screens in America. The real problem for independent films is distribution.

Let's scroll back three decades to find out why. The Sundance Film Festival started in 1978 and Miramax started in 1979. In the 1980s, Miramax paved the way for independent American films—it released great movies and turned a modest profit. In 1989, Miramax hit a new high with Steven Soderbergh's first feature *sex, lies, and videotape*, which had played to audience acclaim at Sundance. For a few years, it seemed as though independent American filmmakers would have a solid path to their audiences.

In 1992, Miramax started Dimension, its genre arm. Over the next few years, Miramax overreached and allowed success to go to its head instead of its heart; it overexpanded its budgets and operational size. Harvey Weinstein, who ran Miramax, hungered to make bigger and bigger

movies—more films like Anthony Minghella's $80 million *Cold Mountain*. Bob Weinstein, Harvey's brother, ran Dimension Films and made movies like *Scream* and *Scary Movie*; eventually Dimension would outearn its more serious-minded sibling's fare and would cash-flow the whole company. Success compromised the indie impulse.

At the same time, the major studios were being swept up in a wave of corporate mergers and transactions. Sony bought Columbia in 1989. The same year, Time, Inc., merged with Warner Communications. Matsushita bought Universal in 1990; Viacom bought Paramount in 1993; and in 1995, Seagram bought Universal from Matsushita and Disney acquired Cap Cities/ABC. With the wave of mergers begun and with more on the horizon, fewer studios exerted greater and greater control of what movies would play on America's movie screens. When it became apparent that even Miramax could no longer hold its screens against the bigger studio movies, it sold to Disney in 1993. Greed was also a factor here—the Weinsteins pocketed $70 million and believed they would be able to finance larger-budget films. If they had kept to their original intention, to the original impetus of smaller independent movies, the Weinsteins would still be running Miramax.

Beginning in the early 1990s, indie movies were distributed by major studios. (Although now I should probably start putting "indie" in quotes, because the nature of the films had changed.) Their budgets were ballooning and the process was becoming more corporatized. In fact, the studios started using the name "specialty" films. Although Disney forced the Weinsteins out of Miramax in 1995, Disney still had an operating indie division. What one studio has, other studios want. Sony had started its Classics division in 1992, and by the mid-1990s Michael Barker and Tom

Bernard were running it successfully. Others followed: Fox Searchlight started in 1994, Paramount Classics in 1998, Focus Features (Universal) in 2002, Warner Independent in 2003, and Picturehouse (New Line) in 2005.

As the 2000s continued, however, the studios, which now were merely small contributors to their corporate parents' bottom lines, took a hard look at their "specialty" divisions. Some of these divisions were profitable; others weren't. They all involved risk, quick decisions, and a lot of person-power. For a variety of reasons—some bottom-line, some political—the studios decided to eliminate their specialty divisions, and one by one, they shut them down. New Line and Warner Independent were killed in 2008. Disney officially fired the Miramax staff in January 2010, after letting the label languish, and finally sold the company in August 2011. Universal essentially let go of Focus Features in 2013 when FilmDistrict took it over and turned it to genre fare. Only Sony Classics and Fox Searchlight remain.

In every case, greed was at the heart of these decisions. The specialty divisions that had operated too large, too much like their studio parents, were the least profitable. The reason to operate large is to covet awards, eat at great restaurants, walk red carpets, and enjoy the glamour; bottom line, it is about greed, about buying status in Hollywood. Companies that tried to buy status destroyed their financial model and lost so much money they drove themselves out of business. At times, the greed came from the studio side—some studios wanted even bigger profits than indie divisions can reasonably create. Paramount's case is a textbook example. Paramount Classics posted a profit every year with an overhead budget just under $4 million and a staff of 16. In 2006, new studio management

replaced it with a new entity called Paramount Vantage, which grew to nearly 100 people on staff and a $25 million annual overhead. Paramount Vantage never posted a profit and lasted only two years.

Some may say that it's because the audience turned away from independent films in favor of bigger-budget studio fare, and that is true, but you have to watch the chain of events. Initially, the studios bought independent distributors or created their own "specialty" divisions. This made the studios seem cool. It appeared to put them on the side of emerging artists. But it was about business, not art. When specialty division dollars were not sufficient in absolute terms (as I said, many of these divisions were profitable overall, but the number of dollars just wasn't that big), the studios started to abandon smaller movies and force their larger product onto the screens that were once available for indie films. Exhibition chains took over independently owned theaters. Indie movies became less visible and less available.

It's analogous to what happens in your local supermarket, where food-manufacturing companies pay for better shelf space and endcap displays, effectively muscling out smaller brands. Movies work the same way. When they are hard to find or don't get adequate shelf space (in the case of movies, when they don't get enough theater screens), the buying public loses interest and finds an alternative. The public develops a taste for what is available.

Today, with no structural path for distribution, indie films still get made. But indie filmmakers have to find new formulas each time. They need to cobble together financing in inventive ways or rely on angel investors who must realize the film may never get released and their money may never recoup.

Today, every indie movie has to start from scratch.

And the filmmakers do it. But their films are not being seen. The flurry of interest in them from a handful of distribution companies does not, as yet, amount to a genuine business change. It may just drive up the prices on a few titles and cause some of them to be sold above their market value.

For example, here's some math. Paramount paid $4 million plus a $10 million marketing budget guarantee (called *P&A*, for "prints and ads") for *Like Crazy* in January 2011 at Sundance. It released the film on October 28, 2011. Its *settlement rate*—the amount the distributor gets from each theater ticket sold—was 42% at most. Therefore, to clear its investment entirely in the U.S. theatrical run, the movie would have had to gross $33 million. However, Paramount could also get some additional income from home entertainment and cable TV deals. So let's say that it might break even at about $28 million domestic theatrical gross. That would require *Like Crazy* to be in the top 20% of box office earners, achieving results better than movies like *Our Idiot Brother*, *Beasts of the Southern Wild*, or *The Kids Are All Right*. Instead, *Like Crazy*'s domestic box office gross was only $3.34 million (and it made only $150,000 internationally).

At Sundance 2014, Focus Features paid $2.75 million for Zach Braff's crowdfunded movie *Wish I Was Here*. Focus released it on July 18, 2014, and eventually the film played on 753 screens. Such a release pattern suggests the marketing budget was a minimum of $8 million (probably more), which means Focus invested at least $11 million in the movie. However, it only grossed $3.6 million, which means, after the cinemas took their percentage, Focus netted about $1.5 million. There is no way, even with home entertainment deals, that Focus could recoup the money it spent.

But let's get back to those 3,987 movies.

It's one thing to make a product and discover people don't want it. It is quite another thing to make a product and not even offer it to consumers. That's exactly what's happening with indie films as each year more than $3 billion of "product" isn't even offered to the public for sale, all because there are not enough—or the right kind of—distributors.

Did somebody just say "market opportunity"?

The timing's ripe for new distribution companies, and energetic new players, like A24, are beginning to emerge. I'm carefully watching several disruptive companies that are launching, built with a socially networked digital model of marrying filmmakers, crowdfunding, and interactive communication; to be viable, these companies will need to attract quality films and provide theatrical distribution for at least some of their movies. In the near future, we should see new theatrical distributors open their doors with significant financial backing. That's good, because Fox Searchlight and Sony Classics can't significantly increase their current output. Other, smaller distributors, like IFC and Magnolia, have high volume, but their business model doesn't give indie films a strong nationwide release. (IFC acquires indie movies inexpensively, to feed its cable channel, and gives them a theatrical release primarily to get some reviews that will promote its channel's offerings.) So, despite the thousands of independently made films each year, there is scant viable theater distribution for most of that creative effort.

Until enough new players enter with viable, alternative distribution strategies, indie movies will be all dressed up with no place to go. Funny thing is, we all pretty much know what the viable strategy will be: lean overhead, with

financing independent of the studio model; fair deals for films and filmmakers; reinvented marketing and audience-community building using available technologies and social networks; and distribution to every possible screen and device. Plus plenty of ready cash, to make quick moves and acquire companies and platforms as well as movies.

I've been surprised at how long it has taken to get new distribution companies going. Part of it is inertia, because it's hard for some well-paid executives to leave their comfortable "consultant" gigs and try being entrepreneurial. Part of it is investor fear, which seems irrational to me, because it is so much safer to invest in a portfolio of films being distributed, instead of bankrolling a single movie. Many investors won't take the time to understand how and why distribution makes sense; they think it is so much more glamorous to produce a movie. As most of these single-movie investors will soon discover, their movie will never be seen—because there are so few viable distribution companies.

For example, I'm aware of one investor who ponied up $25 million to bankroll one picture. It will not get distribution, and his entire investment will be a write-off. For that same $25 million, he could have financed a distribution company with a hefty P&A credit line. With a new distribution company, he might have brought 100 movies to audiences over the next five years. Why didn't he do that? Perhaps he did not want to give over managing authority to professionals who understand the business, did not want to build the new company over time, or, more likely, did not want to see his name omitted onscreen as "Producer."

You may be thinking, "Lots of those unsold Sundance films aren't good enough for people to want to see them."

You're probably right. But enough of them are good enough for specific audiences to find them worthwhile. If only 1% of those movies could find their audiences, that's another 40 viable films each year where artists would have their work seen and be able to connect with their public.

The revolution will arrive when a critical mass of new distribution companies enters the scene to work in partnership with entrepreneurial filmmakers. For that to happen, venture capitalists will need to get bolder, artists will need to get vocal, and audiences will need to express their dissatisfaction. Because now, entrepreneurs are missing their chances, artists are seeing their work go to waste, and audiences are being force-fed a diet of films that are only a fraction of what should be, and could be, available.

WHO WILL BE
THE NEW MIRAMAX?

Who will be the new Miramax? The new patron, creator, distributor, and promulgator of great independent cinema?

Miramax, as you just read, was the company founded by Harvey and Bob Weinstein in 1979. This new upstart company revolutionized American and global independent film. Until Miramax was sold to Disney in 1993, the name Miramax was synonymous with quality, daring, indie movies.

More than 20 years have passed since 1993, and no new single, strong voice for independent films has emerged.

Today, there's a major disconnect happening in the world of movies, one that's left a gaping hole on our cinema screens. Studios are making fewer movies than they have in decades. Many independent distributors have gone out of business, and while some new companies are emerging, it's unclear whether any of them has the leadership, vision, and sufficient capitalization to restart the marketplace. Audiences are hungry for alternatives. So are exhibitors—the people who run cinemas. Which brings me back to the original question.

Who will be the new Miramax?

The movie world is different today than it was in 1979. It's not certain that, if Harvey and Bob founded Miramax today, they could have the same impact. Their current company, the Weinstein Company, certainly releases great movies, but it lacks the raw energy and game-changing potential of its predecessor.

Cinema has been irrevocably altered by disruptive innovations—in filmmaking, distribution, and financing. The digital

revolution has put a movie studio in everyone's pocket; mobile devices allow us to shoot a movie in HD, edit it, and distribute it to YouTube and other platforms. Just because everyone has a camera doesn't mean everyone's a filmmaker (they're not), but the core tools for moviemaking have become miraculously cheap and ubiquitous.

For distribution, as long as you don't care about getting on a cinema screen, you can distribute yourself via a host of video sites. That doesn't mean you'll get money for your movie, or even eyeballs watching it, but at least you can get it out there.

Then, there's financing. Crowdfunding didn't exist five years ago. With the advent of Kickstarter and indiegogo, crowdfunding—which gives audience members the opportunity to help finance a movie, without requiring the filmmakers to surrender any equity—has opened another source of money (and audience engagement) that previously didn't exist.

All of this puts incredible power into your hands if you, as a filmmaker, have the drive, spirit, and commitment to quality to use your power well.

In this revolutionary landscape, you need to be prepared.

Use this book as your field manual, your map, your navigational instrument. It will teach you how to get your movie made and take advantage of the revolution.

Who will be the new Miramax?

The new Miramax won't be one company. The democratization and disruptive innovations of cinema have so irrevocably altered the landscape that no single company can control the indie movie market or the audience's mindshare. There are too many niche audiences, too many social networks, too many filmmakers.

In fact, the new Miramax won't be a company at all. The new Miramax will be a thousand Miramaxes—filmmakers who follow their vision with fidelity and intelligence.

Filmmakers who are smart about using their investors' money, who understand the rules of creating value for their audiences, sales, and distribution companies; filmmakers who know how to play the festival circuit and ply the social media circuits, to offer their films at any time, in any way, on any device, that their audience wants.

The revolutionary indie movie landscape is full of promise and suspense. Who will be the new Miramax?

If you can navigate this landscape, it could be *you*.

THE EIGHTH **STUDIO**

With an annual production budget that exceeds $3 billion, independent movies rival the major studios' spend on filmmaking, even as indies vastly outstrip the studios in sheer volume.

There are seven major movie studios: Warner Bros., Disney, Universal, Sony/Columbia, Lionsgate, 20th Century Fox, and Paramount. We can now reasonably call independent filmmakers the Eighth Studio because their aggregate production expenses clearly put them in the major studio league.

I don't believe anyone has ever attempted to quantify the amount of money spent on independent films before. To do this, I decided to use Sundance as a bellwether of the entire independent film sector; with more than 4,000 feature-length films submitted each year, Sundance certainly represents a healthy sample of the industry. While absolutely every indie movie isn't submitted to Sundance, the highest-profile ones generally are. So the Sundance submission numbers represent a good statistical estimate of the most viable indie movies produced each year.

Then we needed to make an estimate of how much money had been spent on each film. After speaking to a dozen producers, sales agents, and indie financiers, I settled on $750,000 per movie, as a blended average number. A few people urged me to estimate a higher number. Even though some movies are made for less, many are made for

far, far more, which would put the average cost over $1 million. I decided to keep this estimate at $750,000 to stay on the conservative side.

We can also estimate that more than 400,000 people work on indie movies each year, assuming that an average of 100 people work on each film, through all phases of production and post-production.

Still, the overall picture is far from pretty, and if we were to do a balance sheet for the Eighth Studio, the indie film industry, it would be bleeding more red than a Nicolas Winding Refn movie. Fewer than 2% of the fully finished, feature-length films submitted to the Festival will get any kind of distribution whatsoever. Of the more than $3 billion invested annually, less than 2% will ever be recouped.

As entertainment industry reporters Brooks Barnes and Michael Cieply wrote recently in the *New York Times*, most independent filmmakers must "face the reality that most of the esoteric fare will land on small screens, not big ones"—if on any screen at all.

Does that mean investors shouldn't bankroll indie movies and filmmakers should stop making them? Of course not. But I do wish that financiers would invest more wisely, with seasoned guidance and a clear plan for distribution beforehand, and that filmmakers would concentrate on crafting far better movies. Creators and audiences alike would be better served with higher quality and lower quantity. The numbers make that abundantly clear.

WHAT MONEY **MEANS**

Since we're talking about numbers and this book is about making you money, let's acknowledge the problem with money.

Whether you are a small theater owner or a highly paid film studio executive, you are facing calculations of the marketplace and creative work, and those forces are often at odds. As a film producer, I can work on a movie for years, deploying millions of dollars and investing thousands of hours in time. I can fall in love with the film, the director, the actors' work, and the story.

Then one day, a Friday, the film opens to the general public. At that instant, the criteria for success changes: no longer is quality measured in terms of creativity; it is measured in terms of dollars, per-screen averages, and competition in the multiplex marketplace. Forever after, that film will be judged as a success or failure based on its profit, not its art.

But who's made this shift in judgment? Not the general public, who just came to see and enjoy a movie. Instead, this shift was made and publicized by the mass media's sensibility for naming "Top 10s" and "Winners" in numerical terms, which tells us nothing, of course, about any values other than those of the marketplace.

The problem is immediate and it also affects our future. The movies, books, music, and television shows that become cultural influences—and will determine what proj-

ects get "green-lit" next—are those that make a lot of money. In our current climate, if *Avatar* hadn't made a ton of cash, it would not have been able to influence the next generation of filmmaking. We've allowed dollars to become our aesthetic gatekeepers. When art becomes commodity, with success measured only in dollars, the system fails, as it does in any other industry that has only a financial bottom line.

As the sages have said, "Your greatest strength is your greatest weakness." Indie filmmakers' lack of concern for personal profit has made the overall quality of indie films weaker. Yet your greatest weakness could also be your greatest strength. If you side with art over commerce and quality over quantity, you can make your films stronger.

I. INSIDE TRACK: CONCEPT

The core of your movie

Imagine yourself a pupil, sitting at the feet of a Zen master. "What is large, and also small?" asks the master.

You look up, quizzically.

The master continues: "What contains everything, yet is almost nothing? What is difficult to discover, yet easy to understand?"

I don't know the Zen answer to this riddle, but I know the movie answer: it's a concept—the smallest, largest, most all-encompassing, infinitely compact, confusing, approachable, and necessary thing in filmmaking.

Concept is also the beginning and end of every conversation in the movie business, and because of that, it's your first Inside Track.

1. WHAT'S THE BIG IDEA?

A group of financiers is sitting around a table when an executive or producer shares an idea for a movie. If it's going to be sold, it happens in an instant. Everyone nods their heads in unison. "That's a great *idea* for a movie," they say.

What's a *movie idea*?

A movie's idea is its *core concept*, the big idea that makes you say, "I want to see that right now!"

The bigger your movie idea, the faster it will get sold. That's why you need to make sure your movie has a great core concept, a gigantic, memorable, unique idea at its center.

In this Inside Track, you are going to learn how concept governs *everything*.

It governs whether your movie gets financed. Whether your movie gets distributed. Whether people pay to see it.

Why am I telling you all this now? Shouldn't you just make your movie and figure out all that stuff later?

No, you should not.

When we, as producers, executives, financiers, or distributors, evaluate your project, we don't try to figure out if you can make the film. We try to figure out if—once the film has been made—we can make money with it. We try to figure out if we can sell it.

Selling to financiers means building a convincing

case that the film will sell to audiences. Therefore, you must, in effect, plan your marketing in advance, even before you make the movie.

You need to see long lines of people waiting to get into your movie on opening night—and you need to understand what will bring them there.

You need to see the end at the beginning.

2. **HIGH CONCEPT**

In the 1980s, legendary executive Michael Eisner coined the phrase "high concept." Since then, that phrase has been derided even as many people wonder what it really means. It's no longer used in the entertainment business, because it seems like a relic of the past.

Yet the concept behind high concept is as useful as ever.

"High concept" means that the idea of your movie is so big, so clear, so forceful, that it's really easy to understand.

Think of a high concept like a landmark you can see when you're in an airplane at 35,000 feet. It's got to be huge, defined, and crystal clear. If your movie has such a big landmark idea, it has a high concept. The higher your concept, the more likely your financiers will believe audiences will want to buy tickets to your movie. That makes it more likely financiers will give you money.

3. THE WORLD

Coupled with a movie's concept is *the world* in which your movie takes place. This is your arena. Just as gladiators fought in the arena, your movie will go into the gladiatorial combat of a weekend when other movies are opening, and will fight for the audience's entertainment dollars.

The world is *the setting* for your movie. Often, a setting is the unique characteristic that makes a film enticing and exciting. On the other hand, the world may also be an attribute that disqualifies your movie from distribution or financing. For example, what if a competitive movie takes place in the same world? Financiers or distributors may think, "The audience has already been there, done that (or will have been there, will have done that)."

Let's say your movie is set on a military base; that's the arena or world of your film. From the audience's point of view, the financiers will ask themselves this question: "Do I want to spend two hours on a military base?" If the answer is yes, then that's a great world for a movie. If the answer is no, then it's not a great world. If there have been five other movies recently set on military bases and the audience has grown tired of that world, it's not a good world for your movie.

Here are examples of worlds: a space ship, period England, a rural farm, a futuristic city, New York City's gritty streets, a Southern town, Paris in its romantic splendor.

As you can see just from the descriptions of these

worlds, you have an instinctive emotional response as to whether you'd like to visit them. A movie is a trip, a voyage, a mini-vacation. Your movie must take place in a world where the audience wants to go. The more unique, attractive, and exciting you can make the world of your movie, the more likely you can get your movie sold.

4. THE TITLE

Titles are hard; titles are important.

Most indie movies have terrible titles, titles that turn off audiences and feel weary, stale, and flat. Such titles are, almost always, unprofitable.

Your title should be spectacular. Your title is a way to grab people's attention, to tell them more about your movie.

You cannot copyright a title. However, in the movie industry, titles are registered with the Motion Picture Association of America (MPAA) to prevent duplication and confusion in the audience's mind.

Only companies that are members of the MPAA can register a title, so that's not something you can do right now unless, of course, you already work for one of those companies. What you *can* do is think of a title no one else has used for a movie before, one that succinctly defines your story for your audience and *fits into the genre* of the movie you're going to make.

For example, let's say you plan to make a scary ghost story and, in your movie, the name of the ghost is Emily. Would *Emily* be a good title for the movie? No, because *Emily*, as a title, doesn't really say you're going to make a scary ghost story. *Emily* could be a romantic comedy. *Emily* could be the story about a 16-year-old Olympic swimming champion. *Emily* could be a biopic about poet Emily

Dickinson. *Emily* doesn't say "ghost story." Instead, if your title is *The Blair Witch Project*, or *Ghost*, or *Sinister*, or *The Cabin in the Woods*, you begin to define the audience's expectations with the title alone. That's a good thing.

5. **IT'S ABOUT A GUY WHO . . .**

How do you describe the story of your film? You need to be able to tell its story simply and describe it in terms of your principal characters.

Like this . . .

It's about a guy who puts on a bat suit and defends Gotham City.

It's about a woman who goes to Paris after her divorce and falls in love again.

It's about a group of teenagers who go to a cabin in the woods and discover it's haunted.

Each of these makes the movies' concepts even clearer and includes the worlds in which the characters find themselves. Now, try finding a way to express your movie in a simple sentence.

It's about a man, a woman, or a group of characters who . . .

If you can't, your concept isn't clear and you need to go back to the beginning to get your concept clear.

6. CAN YOU SAY IT ALL IN A SENTENCE?

Any good idea can be said in a simple sentence; movies are no different. This simple sentence is probably like the sentence you just read about ("It's about a guy who . . ."), but it should have greater detail, richness, and singularity. When movies are sold, they're sold with a single sentence to a room full of financiers or distribution executives. When movies are being marketed, they're sold in a headline to potential audience members, also using a single sentence. The audience wants to know in one compact, elegant sentence what your movie will be about.

The inside track to getting your movie made in the first place is to figure out what that sentence will be in the last place. If you can figure out that single sentence and hew to it strongly through the entire filmmaking process, you will make the movie you intended to, and it will be the movie that you sell.

In the motion picture business, these single sentences are called *log lines*. You'll find log lines floating throughout the industry: on the reports that agencies maintain for internal use when they're informing actors and directors about projects to consider, on studios' databases where they're keeping track of their projects, and on dozens of entertainment websites that track releases and tell audiences about what's coming next. The clearer and better your log line, the clearer and better your movie can be.

7. LOG LINES THAT WORKED

Often, log lines begin with words like "After," "When," or "During." This follows Aristotle's principle of good drama: start in the middle of the action, *in medias res*. Then the log lines establish the main character or characters quickly, suggest the challenge or obstacle they'll face, and promise what could happen next without revealing it, which creates suspense.

Here are some examples of log lines:

- In pre–Civil War America, a free black man from upstate New York is kidnapped and sold into slavery, which he endures for 12 years before reclaiming his freedom.
- Two teenagers battling cancer, and coming to terms with life and death, meet in a support group and fall in love.
- When five college friends vacation in a remote cabin in the woods, they become victims of a horrific, supernatural ritual.

Can you express your movie in a strong, compelling log line? If not, well, you know what to do.

8. WHAT DOES IT LOOK LIKE?

Movie posters are called *one-sheets*. Every one-sheet has a single, strong image that defines the movie. Do this experiment with yourself: think of the last movie you saw. Can't you instantly imagine the poster or one-sheet that went along with that movie, that single, compelling image that declares, "This is the movie you're about to see"?

This powerful, unique image is also called the *key art*. As you begin to design your movie, you need to make sure that you have a strong idea of what your key art could be. Of course, by the time you're done with the process of making and finishing your movie, the key art may change. In fact, it *should* change. Right now, your key art won't have the advantage of having real cast members or real images. But what your key art *can* have right now is an image of a strong character (even if it's a prototype character) set in a specific world.

The more strongly you can imagine your key art, the more strongly you can imagine your movie—which means you will be able to tell people about it in bolder, more defined terms.

9. WHAT'S THE TAGLINE?

Just as every movie has a single piece of key art, it also has a single tagline that, when coupled with the key art, defines the film in the audience's mind.

A tagline is a few words or a simple sentence that defines the movie. Here are some examples:

- The story of a nobody who saved everybody. (*The Lego Movie*)
- You're Welcome. (*Guardians of the Galaxy*)
- Don't believe the fairy tale. (*Maleficent*)
- What Makes You Different, Makes You Dangerous (*Divergent*)
- Family vs. frat (*Neighbors*)
- Propose to this cop's sister? Rookie Mistake. (*Ride Along*)
- They don't have forever, they have each other. (*The Fault in Our Stars*)
- Starting from scratch never tasted so good. (*Chef*)

One of my favorite taglines is from an older movie, the classic *Deliverance* directed by John Boorman. The one-sheet shows four middle-aged men in the midst of white-water rapids. The tagline reads, "This weekend, they didn't play golf."

Study the beautiful, clearly delivered context of those

few words. They tell us the movie takes place over a compact time frame, a weekend. Only six words tell us what these men normally do: they're weekend warriors; they're executives who are probably flabby, not really up to the rigors of outdoor life, the kind of men who, on a weekend, might shoot nine holes, then have a glass of scotch. These six words set up suspense, danger, and curiosity about what might befall them.

The tagline you begin with will not be the tagline you end with; now you're just trying to sell your movie, and you haven't made it yet. But you should try to imagine a terrific tagline and then come back to it when you're ready to sell your movie. Having a great tagline crystallizes the idea of the movie for your potential financier.

10. **THE TRUTH TEST**

The combination of title, key art, and tagline, all governed by a unifying concept, sells movies; it convinces your audience to buy a ticket. After you spend at least a year of your life making your movie, success will come down to this "truth test":

Will two audience members go to your movie on opening night?

Why on opening night? Because unless you build up enough anticipation to motivate your audience to go see your movie on opening night, instead of anything else they might do, it's unlikely your movie will play more than one week in theaters.

There's a lot of competition for theater screens. Theater operators are always trying to find a movie that will attract more ticket buyers. If your audience doesn't want to see your movie on opening night, they'll probably wait for it to come out on home video; then theaters will get rid of your movie as quickly as possible.

In fact, on the Monday after a movie opens (movies generally open on Friday), distributors and theater exhibitors (the people who run the theaters) engage in heated negotiations about whether movies will be able to carry over to the following week or whether they'll have to vacate the screens to make room for the next batch of movies.

And who are those two people? Very likely the two

people who must agree to go see your movie are two women.

Why two people? Generally we go to movies with other people: with family, friends, lovers, spouses, partners. Why two women? In most male/female couples, women are generally the decision makers about where entertainment dollars are spent. Don't call me sexist—check out the marketing research. For this truth test, you need two people to agree. If one member of the pair is adamantly opposed, there are so many other entertainment choices that the pair will generally find something else to do. So, given the difficulty male/female couples have agreeing on a film, and their tendency to pick another activity if they can't agree, it's more likely that two female friends will make their way to the theater, and more importantly, agree on a film.

So imagine this scenario: there are two women having a discussion about what they can do tonight, a Friday night.

They can stay at home and watch a movie on Netflix, they can cook an elaborate dinner, they can go out for cocktails, they can go to a baseball game, they can do nothing and just hang out and talk, or they can go see a movie. Can you make a compelling case to your potential financiers and distributors that these two women will agree that your movie is the thing that they *must* do tonight above all other things they can possibly do?

The same truth test applies when you know your movie is for other, specific audiences—for men, older audiences, or kids. Can you make a compelling case that two members of your target audience will see your film on opening night?

Unless you can make that case in a compelling, con-

vincing fashion backed up with evidence, it's unlikely people will want to make your movie.

If you can't make this compelling case—if your movie can't pass the truth test—you should think about making a different movie.

11. MAKE YOUR TRUTH TEST NICHE-SPECIFIC

Don't get me wrong: I'm not saying only make movies for a mass market. Because you're working independently, you can't really reach a mass market: you don't have a studio's marketing machine at your disposal.

Instead, make your movie for a small market: a niche market. When you know your audience's niche, you can specifically tell a story your audience members want to experience and determine a direct way to market to them.

Indie movies are by definition niche movies. Common niches are:

- Exposé documentaries, like *The Square*, *Blackfish*, and *The Invisible War*
- Quirky romantic comedies, like *What If*, *Drinking Buddies*, and *Friends with Kids*
- Gay love stories, like *Love Is Strange* and *Behind the Candelabra*, and lesbian love stories, like *Blue Is the Warmest Color*
- Mysteries, like *The Iceman* and *Whitey: United States of America vs. James J. Bulger*
- Period movies based on classic literature, like *In Secret* or *Wuthering Heights*, or a historical true story, like *Belle*

The two people in your truth test should be members of your audience niche—which is why you need to know your niche!

12. **CONCEPTS THAT DIDN'T WORK**

Because concept is so important, it's useful to look at a few movies that prove the point. Here are some examples where the concept was so soft, so unappealing, or so fundamentally unclear that the films did not gain traction in the marketplace.

If you've never heard of these movies, don't be surprised. No traction in the marketplace means no awareness in the popular consciousness.

All of these films were recently released:

- *Jersey Boys*
- *The Fifth Estate*
- *Enemy*

I chose these examples because even pros make movies with flawed concepts. These movies were directed by Clint Eastwood, Bill Condon, and Denis Villeneuve, respectively. Not only were they directed by seasoned directors, but they are all good movies, movies that bear watching for their sure directorial moves and excellent acting. However, they didn't sell tickets, because their concepts were not clear or appealing.

How will your concept stand up to the scrutiny of the marketplace?

13. CONCEPTS THAT WORKED

On the other hand, some movies have strong, clear concepts, and they get the benefit of strong ticket sales because the audience knows what it is buying.

Of course, most big studio movies have strong concepts, but if you're reading this book, you're probably not making a big studio movie. *Spider-Man*, *Batman*, and *The Bourne Identity* series, for example, are clear, strong concepts that need no introduction. However, some independent movies have strong concepts, too. Just by naming these titles, you'll get it—because I guarantee you have heard of these movies:

- *The Grand Budapest Hotel*
- *Heaven Is for Real*
- *Oculus*
- *Boyhood*
- *Dallas Buyers Club*
- *Spring Breakers*
- *The King's Speech*
- *The Hurt Locker*
- *March of the Penguins*

With a strong concept, you're ready to take your next step—prove your movie with a financial model.

INSIDE TRACK: **COMPS**

Can your movie make money?

A comp is short for the word *comparative*. Every movie's financials need to be compared to something. A comp is how you answer the question, "Really? This movie is a good business decision? Can you prove it to me?" when you're trying to get your movie made. As in any business, you need to prove there's a market for what you're making. Comps are how we demonstrate that a market exists for the movies we want to make.

14. WHAT'S A COMP?

Whenever a filmmaker goes to a financier seeking funding, the financier will inevitably ask this question: "Are there any other movies like this one that have made money?" If the filmmaker has a list of comparable films—*comps*—the financier will start to feel comfortable with the movie in question. If not, it will be an uphill struggle, and the filmmaker probably won't reach the summit.

Let me give you an example. I love Westerns. If I could, I would produce a Western movie right now. The problem is that Westerns have not fared well at the box office in recent decades. I don't know why; maybe the idea of Westerns just seems removed from today's urban audiences. But it doesn't really matter, because we're not having a creative discussion about reinventing the Western genre; we're having a *business discussion* about what kind of movie you *can* get made. Unfortunately, I cannot point to enough comparative Western-genre movies that did well at the box office to make my Western an easy sell to financiers.

On the other hand, science fiction movies generally do pretty well. I also love science fiction and I would love to produce a science fiction film. Therefore, science fiction feels like a reasonable genre to explore, because there are a number of science fiction films I can use as comps when I go in front of financiers and distributors.

Finding comps—real comps—is a basic practice in our industry. In this Inside Track, you'll learn how we do it

and how you can do it yourself. Finding comps is a fundamental skill you can use in every enterprise you undertake, because it trains you to practice *evidence-based decision making*: making decisions based on supportable facts, not on your hopes or emotions.

I mentioned "real comps" moments ago, and that phrase underlines the key issue of comps: they must be *honest* comparatives. They must truly be like for like, apples to apples, across all the important categories: budget, rating, language, genre, and star power.

We'll take each of these in turn.

15. BUDGET COMPS

A film's budget translates into the value you see on screen. The budget determines how many days you can shoot, how much equipment you can rent, and how extensive your visual effects can be. For that reason, a low-budget movie really can't be comped against a high-budget movie, because the value on screen will be so markedly different.

When you are trying to find comps for your movie, make sure that they fall in the same budget range. Budget ranges are as follows:

- Under $5 million
- $5 million to $15 million
- $15 million to $30 million
- $30 million to $60 million
- $60 million to $100 million
- Over $100 million

You'll notice there's a pretty big spread in the budget ranges I just gave you. Movies made for $15 million and $30 million may seem light-years apart, but they're not. A $30 million movie *is* drastically different from a $100 million movie, but, surprisingly, it's not really that different from a $15 million movie. In fact, a $15 million movie may get made with the same stars and locations as a $30 million movie, depending on who finances it.

If a studio makes the movie, it might cost $30 million.

However, if it's made independently, by creative artists who are trying to do something they care passionately about, it could only cost $15 million. Why? If the people involved think of making the movie as a "job," as a work-for-hire, as something they're just doing for a studio paycheck, they will, of course, charge their full rate and the budget will be $30 million. On the other hand, if they're doing it out of love and passion, they will only expect their low-budget, indie film rate and will ask for a piece of the back-end. Voilà! Now the movie only costs $15 million. For that reason, the ranges I've provided are fairly broad and will give you a lot of flexibility in devising your comps.

How do you determine the budget for movies you're trying to compare? It can be tricky. It's typical for studios and production companies to lie about films' actual budgets. Often, independent producers lie upward. They want distributors to think they spent more money making the movie than they actually did, because that allows them to negotiate for higher distribution guarantees.

On the other hand, studios lie and say budgets are lower than they really are, because they're embarrassed about how much their movies cost. For example, I'll reveal right now that *The Dark Knight Rises* cost $400 million (the actual production budget, not including marketing costs). Warner Bros. still officially claims it cost $250 million, but insiders have told me differently. Probably only a few people know the real number, and I'm not one of them, but I do assume it was closer to $400 million than $250 million.

However, there is hope. In recent years, movie budgets have become more public. I've found that by doing a web search and entering the title of a movie and the word

"budget," I'm usually able to find news articles or websites that report the approximate budget of most films. If you can find a couple of reported budgets for each of your comparative films and take the average of the budgets reported, you'll often be accurate within 10%.

16. **RATING COMPS**

The rating for your comparative movies must be the same, because different ratings appeal to different kinds of audiences. For example, all comedies aren't comps for one another. An R-rated comedy will have a heavy raunch factor and won't be appropriate for family audiences. A PG-rated comedy will be so tame that young adults probably won't want to go see it.

Here are some examples of comedies that are in the same rating category that could be considered comps for one another:

R-RATED, RAUNCHY COMEDIES

- *22 Jump Street*
- *Neighbors*
- *A Million Ways to Die in the West*
- *Let's Be Cops*
- *Sex Tape*
- *Bad Words*
- *Bad Grandpa*
- *21 and Over*

The same holds true for all other genres. When you're making a list of comps, the ratings must be the same.

17. LANGUAGE COMPS

The movies you're comparing must be in the same language as the movie you want to make. Which, I hope, is English.

I love foreign films and I don't mind watching movies with subtitles. In fact, I like subtitles because they help me improve my language skills and give me a feeling of seeing a film as its filmmakers intended. When I'm watching a film with subtitles, I soon forget the subtitles are there; later, as I remember its scenes, I even recall the characters talking to each other as if they were speaking a language I understand fluently.

However, audiences don't feel as I do most of the time. *Slumdog Millionaire* notwithstanding, the American movie-going public has a general aversion to subtitles. Financiers and distributors, domestic and international, do too, especially because subtitles play even less well on smaller screens such as televisions or tablets. Therefore, English is the language of choice in cinema worldwide. In fact, a number of internationally produced films shoot in English because they command higher ticket sales that way. Thrillers made by French companies, such as *Lucy* and *Taken*, are perfect case studies.

However, you may be making an independent movie in a language other than English; that's fine. I support you as an artist. In this case, your comps must be in the same language as your film. If you're making a French-language

film, your comps must be French language. If you're making a Mongolian-language film, your comps must be Mongolian language. Don't laugh; there's actually a big difference in the audience that will go to see a movie in French or a movie in Mongolian.

I should know. The first movie we released when I was president of National Geographic Films was *The Story of the Weeping Camel*, which was a Mongolian-language movie. When we released it, in partnership with the now-defunct ThinkFilm, it became the highest-grossing Mongolian-language movie of all time. It made $1.7 million! A couple of years later, our record was broken by the film *Mongol*, which made $5.7 million. But note that no Mongolian-language movie has *ever* made more than *Mongol* did, and the few that have been released made substantially less than *The Story of the Weeping Camel*. In other words, there's probably a box office ceiling on Mongolian-language movies.

On the other hand, Italian-language movies have fared much better. To date, the highest-grossing Italian-language movie in the U.S. is *Life Is Beautiful* ($58 million). Although there are more Spanish speakers than Italian speakers in the U.S., Spanish-language movies have not fared as well; to date, the highest-grossing Spanish-language movie in the U.S. is *Pan's Labyrinth* ($38 million).

Language matters.

18. GENRE COMPS

Genre is a film's ideology; it is the tone of your movie and the style in which the characters' stories are told. Genres have conventions and suggest a set of criteria by which they will be judged. Most importantly, genres set up expectations in the audience's mind.

If you know you're going to see a comedy, you expect to laugh. If you know you're going to see a thriller, you expect to be on the edge of your seat. A comedy would not be a good comp for a thriller, and a thriller would not be a good comp for a comedy. When you're making comps, make sure you're comparing movies in the same genre.

Here is a list of some of the primary movie genres:

- Action
- Action Comedy
- Adventure
- Animation
- Comedy
- Concert/Performance
- Documentary
- Drama
- Family
- Horror
- Mockumentary
- Musical
- Romantic comedy

- Science fiction
- Teen comedy
- Thriller
- Western

This list is not complete; you can find a long list of genres (some so fanciful I'm not sure they really are genres at all) on BoxOfficeMojo.com at http://boxofficemojo.com/genres/.

19. **STAR POWER COMPS**

Because you're probably making an independent film, you may not have access to the same A-level casting as studios do. There are a number of reasons for this, and we'll discuss them in Tip 37, but for now, as you're making your comps, make sure that you're comparing movies with the level of casting you can achieve.

A movie about two dysfunctional people in a romantic relationship might star Ben Stiller and Cameron Diaz, and instantly, because you know who those stars are, the film snaps into focus. It's going to be a funny, character-based, idiosyncratic, probably raunchy R-rated comedy. The fact that those stars are in the movie gives the movie a certain kind of value, and unless you are able to cast stars of the same level, this movie will *not* be a good comp for your purposes.

On the other hand, when *The Spectacular Now* was made, Shailene Woodley and Miles Teller were not big box office movie stars; they were just damn good actors. And if you're making a low-budget romantic comedy, *The Spectacular Now* might well be a better comparative than *There's Something About Mary*, simply because Ben Stiller and Cameron Diaz were stars when they made that movie, and Woodley and Teller were not yet stars when they made *The Spectacular Now.*

20. **HOW TO FIND COMPS**

Sometimes it can be difficult to remember what movies will be good comps. Here's a trick I use and have used when working at major companies. It's free, it's easy, and it works.

Amazon has developed great recommendation software. You've probably seen it when you ordered a book or a movie from Amazon. As you scroll down the page, there will be a section that says, "People who bought this item also bought . . ." Then there will be a line of thumbnail pictures of other books or movies that appeal to people with similar interests.

This is your potential list of comps.

Let's say your movie is a low-budget romantic comedy/drama. You might put *The Spectacular Now* into Amazon's search and see the other movies that come up.

Then, look at Amazon's suggestions and see which ones fit the criteria for your comps: movies that are in the same genre and have the same budget, same rating, and same level of star power.

When I tried this technique with *The Spectacular Now*, Amazon suggested *Summer in February*, *Palo Alto*, *The Good Guy*, *This Thing with Sarah*, *In Lieu of Flowers*, and *Barefoot*. Wow, that was easy!

You can also use Netflix's recommendation tool, if you begin with a comp on Netflix. However, Netflix recommends movies differently from Amazon: Netflix takes

your personal viewing history into account when it suggests other titles, so its suggestions are less broad-based and more particular to your specific Netflix account. You can use both Amazon and Netflix and get a good range of possible comps, which you can sift to select those that really fall within the right budget, star power, language, rating, and release date parameters.

21. HOW MANY COMPS DO YOU NEED?

Five.

That's what you need to build a business case.

Without at least five examples of movies that are good comparatives to the one you want to make, it's difficult to make an evidence-based case for your potential financiers or distributors.

If you can find more than five examples, you'll make a really strong case, and there's a good likelihood you will be able to get your movie made.

If you can only find one or two, or can't find any, you should probably rethink the movie you're trying to make.

22. HOW RECENT DO COMPS NEED TO BE?

Within the past five years.

For the entertainment audience, five years is a generation.

Sometimes people come to me and say, "I want to make a movie and it's like *The English Patient*."

I look at them with a raised eyebrow. "*The English Patient*? I loved that movie. But nobody who goes to movies today can remember that movie, or remembers it very well. It is not relevant to the movie market today."

"But it was a great movie," they argue.

"Yes it was," I say. "But that's not what we're talking about. We're talking about an investment decision. You need current data."

If you want to give me a comp, you've got to give me a comp that is recent enough to be relevant. Then it will have market value.

23. NOW THAT YOU HAVE YOUR COMPS

Take a hard look at them. Make sure they give strong evidence that your movie has an audience—use the process of finding comps as a way to make sure you're living in reality, not wishful thinking.

For each comp, pull that movie's

- Title
- Tagline
- One-sheet
- Trailer
- Date of release
- Distributor
- Number of screens on opening day, and number of screens at widest release (available at www.the-numbers.com)
- Budget
- Domestic box office gross
- DVD, VOD, and any other non-theatrical revenue information you can find

You'll use this all later. The titles, taglines, one-sheets, and trailers will be especially helpful references as you create marketing materials for your project.

24. HOW FINANCIERS USE COMPS

Who are the first people you'll have to sell your movie to? The people who will give you money.

If they have any level of sophistication, they will use comps in deciding if they should give you some or all of the funds you need. Financiers use exactly the same process of comparatives I've just described to you. In fact, I learned this system by being a film financier.

Typically, a financier will make sure that there are valid comps and then will run a series of financial scenarios to explore what might happen to the financier's investment. The analogy would be a business plan that shows high, medium, and low possible financial outcomes. In the case of your movie, the financier will run outcomes that are at the high, medium, and low range of how comparative films have done in terms of return on investment (also known as ROI).

There's potentially a big difference between box office results and ROI. They may be related, but they are not exactly the same thing. Financiers want to recover their investment and turn a profit, which does not always happen at the box office. For example, at the 2014 Toronto Film Festival, Paramount paid $12.5 million for Chris Rock's movie *Top Five*, which was made for about $6 million. Clearly the film's investors will get their money back and a nice ROI. But will Paramount? On top of its acquisition price, the studio also committed to spend $20 million on marketing. Paramount's ROI, if any, entirely depends on *Top Five*'s box office and home entertainment performance.

25. HOW FINANCIERS RECOVER THEIR INVESTMENTS

Financiers recover their investment in two principal ways: by *distribution deals* and by *pre-sales*. Distribution deals occur when a distribution company pays for the rights to distribute your movie. Typically this happens after your movie is completed, so the distributor can view it and make an offer.

Pre-sales occur when the financier is able to sell your movie before it is made (or while it is being made) via international distribution arrangements. The advantage for a distributor, in this case, is that an unfinished movie can be bought for less money than a finished movie, and the distributor takes the movie off the market, keeping other distributors from getting it. If your movie is particularly attractive, you may be lucky enough to sell it before you shoot it. Of course, distributors who pre-buy movies are taking a risk, because they can't see the finished film and don't know how it will turn out. That's why they will read the script carefully, pay close attention to the cast and credits of everyone involved, and ask to see some scenes if you have already begun shooting.

Now, let's get back to how financiers recover their investment and make some money, too. Financiers will look at the comps. They'll hope to recover some or all of their money before your movie even gets in front of an audi-

ence, because this provides "downside protection," an assurance that no matter what happens at the box office, at least some or all of the money can be recovered. If financiers believe they can get good downside protection, they'll fund your movie.

In rare cases financiers may be able to recover their entire financial commitment in advance of a movie getting made, and in even rarer cases financiers may be able to be in profit before a single frame is shot. I have had experiences where I was able to pre-sell the entire cost of a movie, and once I even sold a movie for more than its cost, putting us in profit before cameras rolled. That was a movie we literally could not lose money on!

26. HOW DISTRIBUTORS USE COMPS

Distributors, unlike financiers, are on the frontlines when it comes to ticket sales, and their fate depends entirely on how a movie will fare at the box office or in ancillary venues (such as cable or television sales). Therefore, distributors look at comps specifically in terms of box office and ancillary results.

The distributor has to bear two things in mind: how movies like yours have performed, and what it will take to put your movie into the audience's consciousness and pry their entertainment dollars from their wallets. This is the marketing money, the cost the distributor will have to bear to get your movie seen.

Distributors make financial projections that incorporate the cost of buying the rights to your movie plus the cost of marketing it. The marketing cost is often called *P&A*, which stands for "prints and ads." (This harkens back to the time that movie prints were made on film and physically taken from theater to theater. Now prints are digital prints and exist only on hard drives, or may be uploaded via satellite to theater venues.)

Distributors also have to figure in the costs of their own operation, or their overhead. This is incorporated in the distribution fee.

Distributors will take a look at comps in the same process that I just described, and they will also run high, medium, and low scenarios based on that information. They

may also factor in the date of release. Some movies seem to fare better at certain times of the year. When distributors look at comparatives, they will often also compare the time of year, or the month, or even the precise date on which comparative movies were released, to see if they can find a sweet spot on the calendar when it's best to release your movie.

27. EXAMPLES OF COMPS IN ACTION

Here are some examples of comparative movies in three different genres that are truly like for like:

SUSPENSEFUL DOCUMENTARY

- *The Act of Killing*
- *Man on Wire*
- *Blackfish*
- *Leviathan*
- *The Square*
- *Oxyana*
- *Narco Cultura*
- *Let the Fire Burn*
- *These Birds Walk*
- *After Tiller*
- *The Imposter*
- *Searching for Sugar Man*
- *Into the Abyss*
- *The Cove*
- *Touching the Void*

DRAMA

- *Another Earth*
- *Melancholia*
- *Martha Marcy May Marlene*
- *We Need to Talk About Kevin*

- *Take Shelter*
- *Nymphomaniac*
- *Only God Forgives*
- *Blue Is the Warmest Color*
- *Trance*
- *The Place Beyond the Pines*
- *Upstream Color*
- *Under the Skin*

HORROR

- *The Lords of Salem*
- *Deliver Us from Evil*
- *The Quiet Ones*
- *Stoker*
- *Berberian Sound Studio*
- *Oculus*
- *Possession*
- *Silent House*
- *The Cabin in the Woods*
- *My Bloody Valentine 3D*
- *The Woman in Black*

INSIDE TRACK: **SCRIPT**

What's on screen can only be as good as what's on the page

Movies eventually end up as particles. They display themselves as electrons and photons when you watch them on a screen—in the brightness of a cinema screen or the subtle glow of a tablet.

Movies also begin as particles, in the flashing blink of your cursor as you contemplate your script, and in the fervor of your creative process as electrons zip along your neural pathways causing your fingers to type these words:

FADE IN . . .

28. WHY SCRIPT MATTERS

I'm not going to tell you how to write a script in this book; that's for you to work on. Please make sure your script is good, because right now the script is all you have.

There are three reasons why the script is important. First, it is your blueprint for making your movie. Just as an architect draws plans from which a house can be constructed, so too is your script the action plan for getting your movie made. It will become the source everyone will turn to.

Second, the script is your business plan. The script shows the value you will be giving an audience, in exchange for which they will buy tickets. The script needs to present a compelling business plan, because as we executives read a script, we see the movie in our heads. If we "see" a terrific movie while we're reading your script, we'll feel as though your business plan has merit.

Third, you need a good script to get a good movie. Scripts don't lie. If it's not on the page, it won't be on the screen. I've learned this the hard way. There are times I have approved a script for production when the script didn't fully work. In one recent case, the script, which should have made me cry, didn't. The words on the page were just not emotional enough. "But it will be emotional," the director protested. "I love emotion. I make emotional movies." Because the director had done brilliant work in the past, others and I approved the film for production. It was a mistake. The resulting movie wasn't sufficiently

emotional, did not perform well at the box office, and once again proved the rule.

Because writers intuitively know that scripts matter a lot, they are appropriately concerned about people stealing their ideas. But you need to understand that an idea itself is not something you can protect; you can only protect your unique expression of the idea. As an example, you can't protect the simple idea of a movie about young adult cancer survivors. However, the unique characters and situations of *The Fault in Our Stars*—as expressed in the book, the screenplay, and the finished film—are protectable.

The easiest way to protect your work is to register it with the Writers Guild. You don't have to be a member, and you can do it online at wga.org. Registration with the guild shows that you have written the screenplay, and the date you've written it.

Of course, if you are a writer and you sell your screenplay to a financier, whether an independent financier or a studio, you are selling your rights to the screenplay. Get comfortable with this. It is possible you will be replaced as a writer; it happens all the time. The best ways to keep from being replaced are to have good relationships with the director, stars, and the financier and, of course, to continue doing exceptional work.

29. HOW SHOULD YOUR SCRIPT LOOK?

This may be obvious: it should look like a script.

On the other hand, I guess it's not obvious, because I cannot tell you the number of times people submit scripts that are badly formatted, ill presented, and unproofread.

It's not hard to make your script look like a script. Buy a basic scriptwriting software program like Final Draft, and it will do all the work for you. It will set your margins; put your dialogue, characters' names, and action in the right places; and make your page numbers perfect. And you'll be ready to go. There are also free screenwriting programs available for download, notably Celtx (www.celtx.com), which has many of the same features as the for-purchase software, and exports and imports well with industry standard pre-production software.

If you don't care enough to proofread for spelling and grammar, I wonder if I should care enough to finance your movie or even finish reading your script. Remember that spell-check doesn't catch everything; you still need to proofread your script carefully and should probably have someone else proofread it, too. For example, spell-check will not notice if you have used the word *form* instead of *from*, because they're both spelled correctly. Only someone who understands the context of your sentence will know which word you meant. It's hard to see our work ourselves. Other people's eyes are often better than our own.

30. HOW TO MAKE YOUR SCRIPT READ WELL

Here's a fact we don't talk about much in the business: people who finance movies generally don't like to read. Simply put, reading scripts takes up time that most financiers can't stand to lose.

We zip through our scripts because we get so many of them, and we often look at reading a script as a burden. In fact, when we read scripts, we're generally trying to figure out a reason to say no. Why? Because we cannot say yes to all the scripts.

Studios routinely get 25,000 scripts a year. When I was running National Geographic Films, our company got about 10,000 scripts a year. We had to say no 9,995 times a year. So you need to make sure your script reads great.

Because most of us who have to read scripts for a living do not like to read all that much, and because we read so much as it is, we miss things all the time. One trick you must always follow is to *make sure important actions are also covered in the dialogue.* Why? Because most executives don't read stage directions. Stage direction text lines go all the way across the page; most executives skim only through the dialogue, because dialogue lines are short and run down the center of the page. I have often run up against executives who missed important action steps in screenplays because they were not referred to in the dialogue and only took place in the action description. Don't make this mistake.

31. **MAKE IT A PAGE-TURNER**

For people who are professionals in the business, the experience of reading is very much like the experience of seeing: we run the movie in our heads. There is a direct relationship between how quickly we read a script and the level of interest we have in making the movie.

Make your script a page-turner. Make sure it is light on its feet and easy and fast to read. Really good scripts can often be read in 40 minutes even though the resulting movie may last for 2 hours. Why? Because as we read a script, we're not taking the time for long establishing shots or the actual amount of time for intense dialogue scenes to play. Instead, we're feeling the characters, the action, and the forward propulsion of the story.

Write your script so people can *see* the movie; here, too, your script is a selling document.

32. KEEP IT SHORT

Here are three reasons to keep your script short.

First, people don't like to read that much.

Second, short, tight scripts show that you have taken the time to go through several rounds of revisions and have honed the script to the point where it is compact and clear.

Third, it is more efficient.

It is a truism that there is a ratio of 1 page per minute. In other words, 1 page of the script equals about 1 minute on film. However, while the optimal screenplay, according to most screenwriting books, is 120 pages long, most movies do not really last 120 minutes. A good suspense movie or comedy might run 95 minutes, for example. This means you will have a better chance of getting your movie made if it is the right number of pages (read: minutes) for a movie in its genre. A supernatural thriller or an action movie could very well clock in at 100 minutes—therefore 100 pages would be just fine.

You should also make your script short and compact because there's no point in shooting material you won't use. While it's really expensive to have a shooting day, it's really cheap to cut a page. Cut your script down to the number of pages you really need *before* you go to the directing floor, and you will save yourself time, money, and heartache.

33. TOP 10 SCREENWRITER MISTAKES

No matter how many times I share this list, I keep getting scripts and emails that break these rules. So I'm sharing it again.

1. Starting with "Shit" or something like that. I've read so many scripts that start this way: the first line of dialogue, one-third of the way down the first page, is "Shit." It's supposed to make us like the main character because something goes wrong for him, making him more relatable, and he says "Shit." As soon as I see that, I stop reading. It is a lame and tired opening. It worked once, in *Four Weddings and a Funeral*, when the Hugh Grant character says "Fuck," and only "Fuck," a couple of dozen times when he wakes up late. It is hilarious. But (1) it was "Fuck," not "Shit," (2) it was a couple of dozen times, and (3) that was nearly 20 years ago, so (4) it's been done. Next.

2. Giving women guys' names. Sam. Alex. Jesse. Syd. C'mon. First, women with guys' names occur only in scripts written by, well, guys. Second, I know what you're going for—a female lead that men can relate to as well as women. A female who's tall, hot, looks good

in jeans, watches football, drinks beer from a bottle, and digs hotel porn. Well, I will grant that she does have a guy's name, but there is only one Cameron Diaz, and she's not doing your movie.

3. While we're on it, can we stop giving men one-syllable names? Jack, Ben, Rex. *Really?* How about some characters that are really interesting, with names to match. And since we're at it, how come you use a male character's *last* name for the character slug, while you use a female character's *first* name? Because you think the last name emphasizes men's grounded maleness, while a first name shows a woman's femininity? Yes, it screams sexist—and shows you have forgotten that more than half of your audience is female.

4. Speaking of the audience, not knowing who the audience is. Here's a typical conversation. Me: "Who's the audience for this movie?" Screenwriter: Dumbstruck silence. If you don't know who's going to buy a ticket, why did you write the script?

5. Giving me something I have seen before. I don't mean a previous draft—if I thought your first draft was decent and I told you I'd read it again, I will. I mean giving me a script that's so familiar I could have seen it last week or last month or last year, or worse, on Lifetime last night. The audience doesn't want recycled movies, and neither do I. (Unless it's a franchise, in which case the audience does

want a recycled movie. And if I had a franchise to produce, you bet I would be hanging in there for the fifth sequel.) I want genius, wit, and genuine characters that transport me to splendor.

6. Writing "Query from optioned screenwriter" in the subject line of your email. I get dozens of emails like this a week. First, I don't read query emails. Second, from "optioned" screenwriter? It's not like you won the Academy Award. Just because someone I have never heard of (and you don't name) has "optioned" your script, you're supposed to have credibility?

7. Trying to sell me with mash-up comparisons. Those went out of style even before Harvey and Bob Weinstein started Miramax. If I wanted to see *Transformers* meets *Her*, I would just Netflix 'em back-to-back.

8. Telling me I should read your script because the movie isn't expensive to make. This shows you know nothing about the business. Every weekend of every summer, there's at least one picture that has cost $500 million to make and market. Do you think making a picture cheaply is a selling point?

9. Giving me a script that's a slow read. I love great writing, and great writing moves with pace and precision. Even though I read on a screen now, if the pages don't turn, it is bad. Yes, a writer must do a lot of slow, painstaking work to make a script read fast.

10. Giving me excuses for why you can't write. "I don't have time." "I don't have money." "My job gets in the way." "I just get too tired at the end of the day." Get over it. Writers write. Believe it or not, I bless you for doing so.

34. WRITE TO SELL TO INVESTORS

Because your script is your business plan, it will be the primary document investors use to evaluate your project, *after* they have decided that the comps are in your favor.

Investors need to feel the movie will be exciting and intriguing. If you can make investors sit on the edge of their seats, or cry, or laugh, they will feel that audiences will do the same.

Investors also need to feel the uniqueness of your project. You do that by describing the arena or world of your movie clearly and up front—in the first two or three pages. If investors feel compelled by the world of your story, and if you define that world specifically and in an interesting way, there is a much greater likelihood your movie will get made.

Investors who are savvy and production oriented (and I hope they are) will also read your script to evaluate the soundness of your production plan. If you're trying to make a movie for $5 million, don't write a script that will take $25 million to produce. Don't include gigantic special-effect shots, or scenes with thousands of extras you can't afford. Your script must correlate tightly to your budget and schedule expectations. Professional investors, financiers, and studios know the ropes. They will know if your script makes false promises.

35. **WRITE FOR CASTING**

Casting (which we'll discuss more in the next Inside Track) is one of the most important parts of filmmaking. Often, to get your film made, you will need to attract a certain level of cast. In fact, it is typical for investors to approve your movie *subject to* your getting actors from a list they have pre-approved.

How do you get those actors? It begins with the script. Write characters that actors want to play. Here are three ways to do it.

First, make sure the main character's introduction is strong and clear. The star's first line must be a great line; the star's character must have a great star entrance. The star's physical description must be unique and attractive. No actor wants to play someone who is ugly, unattractive, or uncharismatic. Yes, actors often want to play characters that are bad, evil, repugnant, and unlikable—as long as they are repugnant and unlikable in a fascinating way.

Second, the dialogue must be unique, not generic. Actors read a script and imagine themselves playing the role. Step back for a minute and pretend you're handed a script and someone asks, "Hey, can you play that part?" What would you do? You'd look at the dialogue (not the action, but the dialogue) and imagine yourself saying the lines. You'd ask yourself, "Could these words come out of my mouth? Could I play this character in a comfortable, natural, and unique way?" Actors go through the same process,

including, and especially, stars. Stars *will* consider your movie (even if it's a low-budget movie) if the characters are remarkable and unique.

Third, give the star great, emotional turning points, and make the star the principal driver of the action. Stars' characters need to be in control of the story. They need to be the person around whom the story, and key scenes, center. Make sure your star's character is active, not passive; makes bold decisions; saves the day; turns things around; discovers the clue; kisses the romantic counterpart; makes the giant sacrifice; or rides off into the sunset with important character conflicts resolved.

INSIDE TRACK: **CASTING**

Getting the right actors

You may not want to believe that casting matters as much as it does, but it does. You may prefer to think that your script and your own talents are at the center of your project, but they aren't.

It's the *actors* who will say your words and whose faces (in all likelihood) will appear on the one-sheet. You need to get great casting for your movie. In this Inside Track, you'll learn what great casting means and how to achieve it.

36. WHY CASTING MATTERS

I'm sure there are actors whom you naturally want to see, and actors you don't. The rest of the world is exactly the same way. If there is a movie with no actors you've heard of, it will have to demonstrate much higher quality than a movie with familiar actors, as reflected in reviews and positive word-of-mouth from your friends, before you'll see it. In the movie marketplace, we often say that casting adds "value" to the movie, or that casting *is* the value of a movie. When we're selling a movie, we talk about it in terms of its lead actors. "I've got Jennifer Lawrence's next picture," one producer will say. "Nice," a sales agent will respond. "And I've got one starring Benedict Cumberbatch." The cast goes front and center, even before you talk about the concept, the script, or the director. Casting matters a great deal.

Domestically and internationally, different stars are associated with different levels of box office performance. You can see this yourself on the website The-Numbers. com. Each star's box office history is displayed, and this kind of information is frequently used by financiers and distributors in determining comps.

37. **HOW DO YOU GET STARS?**

How do you get your project in front of the actor you want?

While there are no surefire answers to this question, there are some rules to follow.

Don't be shy. Actors may well want to do your project. Actors are not typically in it just for the money; most actors are in it for the challenge and opportunity to stretch themselves creatively. However, to get to the actor, you must go *through* and *partner with* the actor's representatives. The actor's representatives (the actor's agent, manager, and sometimes lawyer) play an important role in the actor's career. They're there, first and foremost, to screen projects and make recommendations, and second, to negotiate deals on the actor's behalf. The agent and manager are not your enemies: they are your friends. People who consider agents their enemies make a grave mistake.

Agents cannot accept "unsolicited material." Unsolicited material means a project that comes from someone who's just written a script by themselves and wants to give it to an actor. There are good legal reasons: the entertainment industry is rife with frivolous "you stole my ideas" lawsuits. At least, I consider most of them frivolous. (There are few original ideas in the world; it's likely that whatever story you're telling has been told thousands of times before.) However, because the cost of a lawsuit is so great, in terms of legal expense, time, and emotional distraction,

people in the business want to reduce the possibility of lawsuits in the first place. Therefore, agents and managers will typically only accept scripts from people who are also in the business and who may be assumed to understand its conventions.

So how do you get your project to the actor you want? You need to do it the right way. Here are four possibilities.

1. An agent or manager may make the submission for you. If you have an agent (or manager), she can give your project to a fellow agent who represents the actor you want. This is the typical way projects are shared among representatives.

2. Your producer can submit the project. You cannot get around this by saying that you are your own producer. If you have a legitimate project, a real movie that has a chance to be made, it is probable that you have involved as a producer someone who has made movies before. The producer can submit a project to an actor's agent or manager and it will be read.

3. Your lawyer can submit the project. Lawyers understand the legal ramifications of submissions. Not all companies take submissions from lawyers, but most do.

4. If you have a financier in hand, the financier can always submit the project as well. Financiers are often the strongest submitters, because when a financier submits a project to an actor's representatives, the representatives will know there's real money available and a deal can be made.

When you're making a submission for a low-budget movie, the representatives have much less economic incentive for the actor to say yes. Representatives work on a percentage basis: agents typically take 10% of the actor's earnings, managers take 10% to 15%, and the actor's attorney typically takes 5%. As you can see, that percentage of a SAG low-budget deal on an independent movie is not the same as the rep's percentage of a $10 million paycheck from a studio movie. So you should expect to make up some of the difference by offering the actor a "back-end" or profit participation, often a very substantial back-end, to compensate for the lost opportunity of not taking a big paycheck studio gig instead of yours.

As an independent filmmaker, *no* actors are beyond your reach, *if* your script is really, really good. In fact, the actors' union, SAG-AFTRA, even has a special service designed to help you understand how to get professional actors into your low-budget movie. It's called SAG Indie (http://www.sagindie.org/), and although it won't assist you with casting, it will guide you through the process of making sure that SAG actors can appear in your film, and show you how you can afford them. Best of all, SAG Indie's services are free.

Remember: actors are looking for challenging roles. If you have followed the guidelines and written a true star part, a part that merits a star's attention, you probably will get an actor to read it. If it's good enough, the actor will probably ask for a meeting.

38. **THE ACTOR DANCE**

An actor will never say yes simply from reading the script. The actor will want to meet and talk about the project and, in all likelihood, will request script changes before saying yes.

This is a normal part of the process. It happens with every movie, including, and especially, studio movies.

Actors have to be choosy; their careers span a finite number of years and they can only do a finite number of projects. Actors must be highly selective in order to make the most of the career time they have.

It is typical for an actor to express interest and give notes on several scripts at once. This is also just part of the dance. Your project will be in contention with other projects (some independent, some from studios); the actor will be looking for script changes that meet his or her approval. At a certain point, you may need to present a deadline; if the actor can't say yes by the deadline, you must move on.

39. **THE PILE-ON EFFECT**

Have you ever wondered how some indie movies get a whole bunch of recognizable name actors?

Like all great journeys, you start with a single step. In other words, you start with the first actor you want—who should be an actor whose work is synonymous with quality. When you offer a role to this actor, make sure you let him or her know that the movie will be made with other actors of the same caliber and everyone will face a "favored nations" deal. This means no one will get more or less than anyone else. There will be no competition over money, credit, or size of dressing rooms!

After you get Actor Number One, go out to Actors Number Two through Five—for different roles, obviously—and make sure they know that Actor Number One is on board. And that everyone is working "favored nations." You'll have the credibility of a significant actor already involved, plus you'll be putting art before commerce. Generally, if you have a script that's good enough to get one great actor and you take this approach, you will succeed in casting other well-known actors, too.

40. THE DIRECTOR DANCE

Casting goes beyond just casting the actor; you have to cast the director as well.

You may plan to direct your script yourself, and that is possible. But you should also be open to the possibility that an experienced director can direct your movie. A more seasoned director may have relationships with actors—relationships that will get actors to say yes.

Whether you're directing your movie or someone else is, the actor will probably want director approval if the actor is a star. The actor will want to meet with a director to make sure they can have a good working relationship. This is also typical. It is a director's first and foremost duty to get the movie cast well. A director who cannot get the right cast for a movie risks getting replaced.

If you're not directing the movie and you are seeking directors, you will need to go through the same script dance with the director as you would with an actor. In this case, you'll want to hire your director first; generally, the actor will want to know who is directing before making a commitment.

A prospective director will give you notes and will expect revisions before signing on to the project. And yes, it is typical for a director to be doing this with several projects at once until one of them comes together. Sorry, that's just the game. Yes, it takes time. Yes, it is frustrating. Yes, you should present deadlines to make sure your project moves along.

If you do present deadlines, everyone will understand. Just make sure to present them up front and clearly, and don't be shy about it. When I send a script to a director or actor, I'll often accompany it with a note that says, "Because we're planning to start production in [name the month], we'll need to hear back within two weeks if you are interested." Good producers enforce deadlines: it lets everybody know that the movie is a moving train and you're going to make sure it gets to its destination.

41. CASTING NON-STARS

There are a limited number of stars to go around. The stars you want may pass on your movie, or they may not do it at the price you can afford. In this case, it's completely reasonable to cast people who are not yet stars. Notice the word *yet* in that sentence; I'll get to it in a moment.

Many independent movies are made without stars. In these movies, the concept and the world, which you learned about in previous Inside Tracks, bear an even greater burden. Some of the highest-grossing movies have been made without stars. *Slumdog Millionaire*, for example, was made without any recognizable stars, but the concept, emotional connection, and the previously unexplored world were so compelling that it didn't really matter.

If you're going to cast your movie with non-stars, there are two criteria you must observe. First, *the actors had better be good.* Don't cast actors just because they're convenient, because they're there, or because they're your friend or sibling or spouse or parent. Cast actors who are amazingly excellent. Your movie will rise or fall on the quality of their performances. Unless the actors' performances are amazing, your movie will not stand head and shoulders above the rest.

Second, *you must cast actors who have the potential to become stars.* Star quality is an elusive thing and always includes these two attributes: charisma and likability. You can only determine star quality in a screen test; you cannot

tell in a room. Some people are amazing and vivacious in a live audition, but those qualities don't come across on screen. On the other hand, some people seem introverted and quiet in a room, yet explode on screen because their emotions are so readily accessible to the camera.

42. TACTICAL APPROACHES

As an independent filmmaker with a great script and limited resources, you will need to take advantage of every relationship and connection you have. Actors can be critical to persuading others to take a chance on your production. Therefore, you should focus on two kinds of actors—those on the way up and those on the way down. Young (and sometimes not-so-young) aspiring actors with talent are frequently willing to work for little and deliver much. The same is true for older actors whose name recognition might still have some minor value to a low-budget film.

Let's assume you're friends with someone who has read your script and is able to get it to an actor whose credits might help lend credibility to your project. Let's say the actor reads the script and is willing to meet with you to discuss it. If all this goes well, you need to secure some way of verifying his or her interest in the project. One way to do this is to get the actor to sign a Non-Binding Letter of Intent. This is a letter that includes a statement that reads: "Having read the script and assuming both my availability and good faith negotiations, I would welcome a chance to play the part of _____."

Does this mean the actor will do it? No. But it does indicate he has actually read the script and would seriously consider taking on the role if a deal can be reached. As an aspiring filmmaker looking to put together a viable production, such a commitment helps establish your legitimacy.

43. CAST THE REST OF YOUR RELATIONSHIPS

You have your comps, your script, your cast, your director. Are you ready to get financing yet?

Not quite. Before you plunge ahead, it is time for one more reality check, so you plunge in the right direction. In the process, you will develop five relationships that will be essential for this movie and perhaps many more movies in your career. In some ways, this is the most important "casting" step of all, because it will keep you from making rookie errors.

1. Begin building your audience platform. "But I don't have a movie yet!" you may object. When you do have a movie, it will need an audience, and it takes time to build an audience. Start now. Think *niche*—the small, core group of audience members who will be ecstatically enthusiastic about your movie. Use Facebook, Twitter, a website, Myspace, Tumblr, YouTube, carrier pigeon—anything and everything that will develop interest in your movie. Crowdfunding, via platforms like Kickstarter or indiegogo, can be especially useful for initiating audience contact. Advance your relationship with your audience through the entire process; share what works and what doesn't, your victories and defeats. Get them

primed and ready to experience your film. When it comes time to seek distribution, you will stand a much better chance if you already have thousands or tens of thousands of people following your film.

2. Audition your project for distributors. While no one will want to distribute your movie yet, if you are in a position to talk to distribution executives, you can pitch it to them and gauge their reaction. If they appear skeptical, try to find out why so you can make some adjustments. It's better to find out now than after you've finished shooting! At the same time, you're developing relationships you will use later, when you are able to tell them your movie is ready to be seen.

3. Talk to agents, sales agents, and film representatives. These are the people who may help you sell your movie for domestic and international distribution. For now, if you can, simply develop some preliminary relationships so you have them. You may call on these people for advice and counsel along the way.

4. Talk to bankers. In the next Inside Track, you'll learn about the role a bank may play in getting your movie off the ground. At this point, you can start getting to know bankers, who will help you understand what they're looking for and if your project may qualify. The best time to get to know bankers is before you need them.

5. Make friends with completion bond companies. Read the next Inside Track to learn about bond companies. They can be essential sources of information about what locations, actors, directors, and post-production facilities are good to work with. You may need a bond to get your movie made, so make bond company executives part of this final, important casting call.

INSIDE TRACK: **COST**

You need to know the numbers

Many people are scared of numbers, yet numbers are an inevitable part of the filmmaking process. Once you have brought value to your project with a great script, a great cast, and a great team, you will be called upon to explain what it will cost to achieve your vision.

Instead of being afraid of this inevitable moment, you should greet it with open arms: your prospective financiers are now so interested, so convinced there's a lot of value in your movie, that they want to know about dollars and cents. At this moment you'll need to be ready with all the answers, and also with the vocabulary of a financier at the tip of your tongue.

44. BUDGET IS FOR AMATEURS, COST IS FOR PROFESSIONALS

When you talk about the budget of your movie, you're still thinking like a filmmaker; when you talk about the *cost* of your movie, you're thinking like a financier or a distributor.

For financiers and distributors, every movie is a cost, an investment. It is money that's going out and may never be seen again. Therefore, financiers are incredibly choosy about what movies they invest in. They evaluate the cost of each movie against the probability of audiences going to see it, the likelihood that the production team can get the movie made, and the value of other movies vying for their investment dollars that they will have to turn down because they have already invested in your movie.

Remember: when financiers or investors give you money to make your movie, they will not be able to give someone else money to make their movie. Your movie represents a commitment and an opportunity gained—but it is also many other opportunities lost.

45. MAKE THE COST RATIONAL

Savvy investors will look at your numbers to make sure they make sense. Most likely, your financier has made movies before. In fact, you should hope so; making a movie with an unsophisticated financier is double trouble. Not only is the financier probably investing in the movie for the wrong reason, but you have to school him or her in the movie business while you're trying to make your movie. That leads to distraction and costly errors.

Your film's cost must be rational. You can't say you're going to shoot an extensive action sequence in half a day, because nobody will believe you. You can't say you're going to shoot a movie with 60 locations in two weeks, because nobody will believe you. You can't say you're going to take ten weeks and $10 million to shoot a two-character, single-location movie, because that would be a dumb waste of money.

You must conform the movie you're going to make to the money you have. You may have to revise your script, because the script is the blueprint. You don't want to go into production unless the script accurately reflects the movie you're really going to make and the funds you actually have.

For example, if your original script calls for 60 locations and you only have $500,000 to make your movie, rewrite your script to make it rational. In this

case, get rid of 50 locations so you only need 10. That would be *rational*. You would follow the same procedure if your script called for large-cast scenes, involved action sequences, or included visual effects that your budget could not support.

46. INCLUDE MARKETING AND DISTRIBUTION COSTS

Your budget has to include everything you will need to get your movie in front of your audience, including potential marketing and distribution expenses.

That's right: you may come to the point where you have to distribute your movie yourself, and it is better to get that money up front than to try to raise it later. As you now know, there are over 4,000 movies made in the United States every year that get no form of distribution whatsoever. You don't want your movie to be one of them. It is also a far better investment for investors and financiers to budget some marketing and distribution expense in the initial budget, because that way they can guarantee the movie will have the opportunity to get in front of its audience.

I recommend budgeting at least $200,000 to $350,000 if you want to assure theatrical distribution, and at least $50,000 if you require only non-theatrical distribution.

If you're fortunate enough to get a deal from a distribution company, you can either give this money back to the investors (they'll be happy) or use it to front some of the marketing costs yourself, which will allow you to exercise more control and keep the distribution fees low.

One note: while I recommend raising enough financing to cover marketing and distribution, you should not put these costs into the production budget document. If you're

making a low-budget movie under certain union and guild agreements, you will need to present your budget so the unions and guilds can verify you are really making a low-budget movie. You will not want to confuse the situation by including marketing and distribution financing, which are not the cost of shooting your movie, as those costs could push your project out of the official "low-budget" range and could thus increase your actor or crew costs.

47. PLANNING AND SCOUTING

Make sure your budget includes adequate costs for where and how you're going to shoot. Until you've done this, you won't really know if your budget is accurate.

For independent films, good locations are essential, because you won't have money to build sets or to rent stage space. The *uniqueness* of your locations makes a massive difference in the audience's perception of your movie. Memorable locations elevate your film; the quality of your location becomes the quality of your production design.

You may need to scout several different states, cities, buildings, or houses, and you should not compromise your vision as long as it can fit within your budget. On the other hand, you won't really know if you can afford a particular location until you have struck a deal with the person or company that controls the location; you'll need to do this as part of your budget planning process.

48. INCENTIVES, REBATES, AND CREDITS

Many states and cities offer incentives, rebates, or tax credits for making some or all of your movie there. The incentives may apply toward production or post-production, or both, and can amount to up to 30% of your applicable budget items. This is also true of all the Canadian provinces, some European countries, Australia, New Zealand, Singapore, and dozens more locations. While film incentives change frequently and you'll need to do some sleuthing to see if your movie can qualify, your research can make the difference between a film that gets made and one that doesn't.

Here are two excellent resources for investigating incentives. The Incentives Office (http://incentivesoffice.com/) offers a free downloadable report that's an excellent guide to production incentives in the United States, and Entertainment Partners has an interactive map on its website at www.entertainmentpartners.com/incentives that provides a terrific global overview. Both of these companies also offer consulting services to help producers get incentives.

Why do governments create film incentives? To build local capacity, create jobs, increase dollars spent in the region, and to bring tourism there after the film is released. Incentives do not exist to help you get your movie made; incentives serve a national, state, or local agenda. Remember this from your first encounter (which will be with a

film commission) and you will put yourself in the best possible position.

In order to receive any of these incentives, you will need to fill out an application. Follow the rules precisely; most incentive programs have more applicants than they have money to fund them with.

Incentive budgets can be uncertain because some states and cities go in and out of fiscal crisis. You need to make sure the money you're hoping to get is really there and does not fall into the government's *next* fiscal year, when the legislature may decide it needs the funds for schools or police. If the money *is* there, you can't just claim it; you may need to get in line because some governments operate on a first come, first served basis. Others hold a lottery because there are so many companies applying for incentives. Still others are picky about which projects they wish to incentivize; they will choose higher-profile projects, often made by studios or with big stars attached, because these projects are more likely to get made and to bring more jobs and tourists to the area.

If you are lucky enough to get an incentive, make sure you have excellent accounting to manage your film all the way through its final release. Incentives are paid retroactively, which means your film will have to front the cash and then apply for a rebate afterward. There have been some cases where rebates were denied because all the rules weren't followed. Make sure this doesn't happen to you.

49. CONTINGENCY

Every movie should have a contingency of 5% to 10%. Bigger-budget indie films can generally get by on a 5% contingency, because 5% of $5 million dollars is, after all, $250,000. On the other hand, if the budget of your movie is only $50,000, you probably need a 10% contingency, and even then $5,000 will not go very far.

The contingency is there for two reasons. First, it gives your investors peace of mind. They need to know that if something goes wrong, you're not going to come groveling for more money. Because if you do, they will feel they didn't do a good job vetting your budget, and they'll feel stupid. And you never want to make your investors feel stupid; then they will think *you* are stupid.

Second, you may need it. Stuff happens. Movies are all about dealing with the unplanned.

You should try not to use your contingency once you have it. Think of it as a security blanket you'll probably never have to reach for. *An excellent time to use the contingency (if you ultimately do use it) is after you have finished shooting.* You may discover the need to reshoot some key scenes, or you may want some visual effects you had not previously budgeted. If you haven't spent your contingency on going over schedule and over budget (and I hope you have not), then you will be able to use your contingency for these additive purposes, with your investors' approval.

Note that investors will *always* demand approval of

contingency spends, and they may deny you that privilege. The very best use of your contingency is giving it back when you are finished. Your investors will feel you have been a good guardian of their resources and will be far more likely to invest in your next project.

50. COSTS YOU MIGHT NOT KNOW ABOUT

MEDIA KIT PHOTOGRAPHY. You must plan to document your production—including the pre-production period—because you will need the material for your media and marketing materials. You should have a photographer who will take still photographs of the key scenes in your movie, as well as behind-the-scenes candid shots; you'll also want to capture video footage for "extra bonus features" and for your website. Plan ahead and budget these costs. They will come back to you tenfold when your distributor sees you are prepared.

UNION OR NON-UNION? There are a number of unions and guilds that govern film production. Virtually all professional actors belong to the Screen Actors Guild. This should not scare you—in fact, the guilds and unions can be your friends and help you get studio-level talent at a fraction of what studios pay. Why? Because all the unions recognize the importance of indie movies, and most have low-budget contracts (even low-low-budget contracts!). To sort out the particulars, you'll want a line producer who understands the rules and a good production lawyer.

LEGAL EXPENSES. I'm not a lawyer, but I will give you one piece of legal advice: get a lawyer. You are going to be entering into contracts with your investors and your crew; your film is a work of intellectual property; you must protect yourself, your investors, and everybody else. Experienced production lawyers can be retained on a "flat rate"

deal, which means they will handle a long list of legal services for a fixed fee—no hourly billing, no sticker shock. You should budget $10,000 for legal expenses on a very low-budget production, and up to $50,000 on a $5 million to $15 million production, depending on the range of services required.

COMPLETION BOND. A completion bond is an insurance policy that you will finish your movie. It will cost 1% to 3% of your budget, depending on specifics, and can be purchased from a completion bond company, which will put you through your paces, vet your budget and schedule, and do everything it can to make sure it doesn't have to pay on the policy. After all, it *is* an insurance company.

While most indie films see this as an unnecessary expense, it's worth considering if your budget is over $2 million, and it may keep your investors happy—it may even get your investors on board. Completion bond insurance can mean the difference between a finished film and disaster. Obviously it means taking on the bond company as your partner to oversee expenses, but filmmaking, as we all know, is a risky business. Because unforeseen events can cripple your production through no fault of your own, hedging your bet should at least be considered.

The leading completion bond companies are Film Finances and Aon. There are also other, smaller companies. Some of them may also offer tax incentive insurance, protecting you in case the government agency doesn't pay out your incentives as expected.

PERMITS, SECURITY, AND INSURANCE. Regardless of the cost of your film, don't forget the costs of permits, police security, and location insurance. Many indie filmmakers "steal" locations—they try to shoot without permits or approval. Sometimes it works, but it is a dicey strategy. You risk get-

ting kicked out, being fined by the police, being shut down, and even getting arrested for trespassing. If someone gets hurt on the shoot and you don't have insurance, you have just put your entire net worth, and that of your investors, in danger.

Sometimes you can find a creative way to pay for locations and even get the owners of locations to cover you under their insurance. A friend recently bartered an office location space in return for shooting a few short promotional videos for the company that owned the building. Who says that deal making isn't creative?

51. PRE-SELLING EXPENSES

Your costs should include the *pre-selling expenses* of getting your movie in front of distributors and international buyers before it is even made. Pre-selling expenses may include developing a mock-up one-sheet, press kits, a "lookbook" of visual concepts, or a sizzle reel, which is a 2- to 3-minute video, drawn from clips of other movies, designed to give the feel of the movie you want to make.

If you have a completely packaged film (with script, director, stars, and budget), you may want to seek some distribution pre-sales. Unless you have been in the business for a long time and are experienced in selling movies, you will need a professional to handle pre-sales for you, and they will provide a cost estimate.

International sales agents typically charge a 20% to 25% commission, and they have real expenses: they must travel to film markets, stay in hotels, buy floor space, and produce brochures and other materials to attract potential buyers. The commission should pay for everything except some specific marketing costs (such as printing a brochure), and you should place a cap, or maximum, on these costs in your contract with the sales agent.

You may also choose to work with an agency (such as WME, CAA, UTA, or ICM Partners) or a producer's representative. Agencies or producers' reps do not take the place of international sales agents—their role is distinct and generally focuses on the U.S. and Canadian markets. Agen-

cies and producers' reps can help you navigate the festival circuit and will help you negotiate distribution deals. They charge for their services in different ways: some work entirely on commission, some work entirely for a cash fee, and others do a mixture of commission and fees. As with all your agreements, make sure you understand the costs fully and in advance.

If you're feeling uncomfortable paying out these commissions, let me reassure you. They will be the best money you spend. People who work on commission are incentivized for your success and only make money when you make money.

52. **SELLING EXPENSES**

Once your movie is finished, the real selling begins—along with the cost of soliciting those sales.

This includes festival application fees. Yes, it costs money to get into festivals, generally $50 to $100 dollars per application. It adds up quickly if you apply to a lot of festivals, and you probably will.

You will also need materials to sell your movie to international and domestic distributors: a one-sheet, a robust website, social media, a blog, and a terrific trailer. The trailer will be the primary means of selling your movie. You may also cut a reel of so-called *selects,* which may last 10 to 20 minutes, showing the principal locations and key scenes. You might use the selects reel before your movie is finished, to give buyers a deeper understanding of what it will be like when complete. Your selects reel has to be excellent; even then, many seasoned distributors will look with skepticism on even the most polished selects reel because they know you have used only your best material and the rest of your footage could be terrible. On the other hand, I have seen situations where a strong trailer, strong cast, strong script, and good selects reel did get a sale, and the finished movie exceeded everyone's expectations.

You should also budget for film market costs the selling agent will incur, which will be similar to the costs you budgeted as pre-sales expenses for film markets.

53. ASSUME YOU WILL NEED TO COVER EVERYTHING

Some filmmakers make the mistake of going into production before they have raised all the money they will need. Don't do this.

Filmmakers who believe they can shoot the movie and then raise more money to finish (so-called *completion money* or *finishing money*) put themselves in grave danger.

It is unlikely you will be able to raise the money to finish your movie. Even if you do, finishing money comes at an extremely high price. Because finishing-fund investors know you are vulnerable (you've probably put the movie on your credit card, you're behind on your car payments, and if you don't do something with this movie, your life is going to be over), these investors often get a disproportionately large share of any potential income.

Make sure you include *delivery requirements* in your initial budget. Delivery requirements are what you will have to have—technically and legally—for a distributor to take your picture. You'll learn more about delivery later in this book. If you can't deliver, no one will be able to distribute your movie.

54. **NOT ALL MONEY IS EQUAL**

We've talked about getting money from your investors and saving money by using incentives and rebates. There's yet another way to get money: crowdfunding, through websites like Kickstarter or indiegogo. What kind of money do you want? Is there a reason to take one kind of money over another?

The answer is yes, and to understand the answer, we need to understand the concept of equity. Equity means cash for ownership. If you are making a $1 million movie, and an investor gives you $1 million, all that money is called *equity* and that investor owns 100% of the equity in the movie.

If your movie makes money, there is generally a 50/50 split between the equity (your investor) and the producer (you), after the equity has recouped all of its investment plus its profit margin, which is usually 20%. Using the $1 million example, let's pretend your movie is sold for $1.3 million. What happens to the money?

First, the equity investor will take $1 million, the full amount of the initial investment. Then the investor will take a 20% profit, which in this case would be $200,000. That leaves $100,000 of *net profits* to be split between the equity and the producer—each will get $50,000.

However, the producer's share has to accommodate all the other back-ends and talent participations. In other words, all of these come out of the producer's share. The

cast might get 10% or 20%; the director (if the director and the producer are not the same person), 5%; the writer, 2.5% to 5%. Much of your $50,000 will disappear quickly.

That's where crowdfunding and incentives make a big difference, because they have no equity participation. If you could get $50,000 from crowdfunding and $150,000 from incentives, you would only need $800,000 in equity in this example. In that case, the equity investor would only be entitled to 40% of the net profits, and you would be entitled to 60%. Better, huh?

It can get better still. Let's say you were able to pre-sell some international rights for $500,000. You'd still have your $50,000 from crowdfunding and $150,000 from incentives, but now you would only need $300,000 in equity investment. In this case, the equity investor would only be entitled to 15% of the net profits, and you would get 85%. That is fantastic!

However, you're probably wondering, where does the cash flow come from? Pre-sales contracts don't pay until the film is delivered, and incentives pay retroactively. You need cash in the bank right now to make your movie. That's why you want to have a banker in your cast of characters. Banks can lend you money using pre-sales contracts and incentive agreements as collateral. Moreover, banks simply charge fees and interest—they do not take an equity stake in the movie.

The best producers get money from as many sources as possible and keep close banking relationships. They get their equity money last, not first, so they never take more equity than they need. Obviously, one could devote an entire book to film financing (and if you've never done it before, please partner with someone who

has), but this short tip has given you the basics so you can ask intelligent questions. Even though it sounds a bit complicated, structuring your money properly and balancing different money sources make the financial terms for filmmakers much better in the end.

55. CROWDFUNDING IS DOUBLE MONEY

I just mentioned one of the advantages of crowdfunding: it is non-equity money, so it does not reduce anyone's profit participation. However, the most important aspect of crowdfunding isn't money. It is about engaging your audience, learning who they are, and opening a channel of communication with them so they will be enthusiastically waiting for your movie on opening day.

That's why crowdfunding is double money.

Every distributor is keenly persuaded of the value of your movie when you have a successful crowdfunding campaign supported by lots of people. This is especially true for digital distribution platforms, and crowdfunding will be an essential ingredient if you choose to self-distribute using the Free Range Distribution techniques you'll learn about later.

A successful crowdfunding campaign is a full-time job and requires human, technical, and financial resources. Think of it as your earliest marketing campaign. While the design and execution of a good crowdfunding campaign has many moving parts and merits a great deal of advance planning, the next three tips will give you the fundamentals.

56. CROWDFUNDING: BE PREPARED

All crowdfunding campaigns, like all films, are made—or unmade—in pre-production. Raising money is never easy and always requires a ton of effort: a crowdfunding campaign is a whirlwind of 24/7 activity.

Follow these six steps to be prepared:

Select your platform. Believe it or not, there are more than 600 crowdfunding platforms. They vary in visibility, in the kinds of communities they serve, and in how they handle money. Some, like Kickstarter, are all-or-nothing, meaning that if you don't raise your full goal, you get zero. Others, like indiegogo, let you keep what you raise, even if you don't hit your target.

Find a platform that feels comfortable for you and that has supported and funded projects similar to yours in the past. The science of comps works here, too!

Put your team together. You will need help. Lots of it. Gather together your supporters and ask them if they will work on the campaign with you. Assign people responsibilities in line with their strengths, and then supervise them closely. Crowdfunding campaigns supported by teams raise 38% more money than "one-man bands."

Prepare your written materials. In 300 to 500 words, communicate the What, Who, When, and Why of your project—especially the Why. Use subheads for easy reading, and simple, direct language. Make sure you explain what's unique about your project, who's on your creative

team, and how the crowdfunding money will be used.

Create your pitch video. Since you're already a filmmaker, this should be easy—but it is different from a feature film. A crowdfunding video needs to be short, fun, and emotional. You must speak directly to the camera, as people will be giving money to *you*. If you can find a way to visualize your completed project, with storyboards, sample scenes, or a lookbook, or by having your key actors on camera with you, do it. Be passionate. Be funny (even if you're making a drama, funny is good). Explain clearly what your movie is about and what the money will be used for. Do it all in less than 5 minutes.

Set your incentives. Incentives are the premiums that people get when they give to your campaign. You should have a range of them—a "low entry point" incentive for smaller contributors, up to big ones for high rollers. Your incentives should be themed to your movie and, once again, they should be fun. Consider digital incentives—incentives that can be non-physical, such as Tweets from famous people in your cast, or a PDF of original artwork. Otherwise, you'll find yourself stuffing T-shirts into boxes and making multiple trips to the post office!

Get ready. You must be ready for opening day, and on opening day, you must be prepared to make your mark. Make sure your team members are at their battle stations. Try to get several donors lined up so they will make significant contributions on opening day—that will give your campaign momentum from the start.

57. LAUNCHING AND MANAGING YOUR CROWDFUNDING CAMPAIGN

Launching a crowdfunding campaign is a lot like launching a movie; in fact, it is a good dress rehearsal for your film's opening night. Because crowdfunding takes place in the public, social media ecosystem, everyone will know how your campaign is doing; there is no hiding lackluster results. Therefore, you need to make sure your results are impressive. Here's how you do it:

LAUNCH THE CAMPAIGN. Launch day is critical to your success. Make it an event. Consider throwing a live launch party and streaming it on your website (remember, with crowdfunding, you have a global audience). You and your team must hit social media hard, driving people to your campaign. Trigger your early donors in the first 24 hours, and try to achieve 40% of your goal in the first week. That will show the public that your page has momentum; in addition, with large early donations, many crowdfunding sites will promote your campaign to their home page or "staff picks" section.

MANAGE THE CAMPAIGN. Just as a movie takes hour-by-hour production management, so does crowdfunding. You should be checking your results regularly and determining which team members are pulling their weight and which are not. Replace the people who do not deliver results. Change your messaging if it isn't gaining traction. You can

monitor your results in real time with web analytics tools, in addition to seeing how fast your cash is increasing. Don't be afraid to shift directions and try new approaches if your initial strategies didn't deliver results. On the other hand, when you find an approach brings in money, amplify it!

WALK THROUGH THE "VALLEY OF DEATH." Most crowdfunding campaigns start strong with an initial burst of energy and enthusiasm, and then taper off. This is the "Valley of Death," and you should expect it and not fear it. It is normal. Keep going. The campaigns that fail usually are run by people who despair and give up in this Valley. The campaigns that succeed are run by people who push through, who keep motivating their teams and get inventive during this period. There is a great reward on the other side of the Valley: successful campaigns, which have kept their energy high, experience a rush of donations in the last week that often push them over the top.

Try to overfund. Yes, you can go over the top. Of campaigns that succeed, over three-quarters overfund—which means they raise *more* than their goal. Campaigns that overfund do everything right: they have strong, well-managed teams, excellent communications materials, and a killer work ethic. You might adopt a strategy of setting your initial goal a bit low, so you can accomplish the overfunding milestone. It looks, and is, impressive.

58. CROWDFUNDING DOESN'T END WHEN THE CAMPAIGN DOES

Once you have hit your financial goal, you now have the opportunity to cash in on the true double-money potential of crowdfunding: being connected with your audience. Because only about 1% of the people who heard about your crowdfunding campaign gave money, you now have some amazing math on your side: 100 times more people now know about your movie than actually made a donation!

Keep communicating with all of them, all the way through your production and finishing schedule. Send them social media posts and video updates. They are your audience, and they will have a second opportunity to give you money, when they buy a ticket to your film.

Simultaneously, ramp up communication with the people who financially supported your crowdfunding campaign. They are your super-fans, and they are highly incentivized for your success. Do special updates just for these people. Successful filmmakers know these folks will become the people who will turn out on opening day, host house parties, and do group sales. Moreover, having a highly engaged fan base even before your film is released will be extremely impressive to distributors and will help you get your distribution deal. A successful crowdfunding campaign that extends all the way up to your premiere is a key to your ultimate destination: the box office.

59. WHAT WILL YOU HAVE TO GIVE UP TO GET WHAT YOU WANT?

Crowdfunding is a unique way to finance films, because the money raised has no strings attached. However, you will probably not be able to finance everything through crowdfunding.

So you will get back to dealing with investors, and you have to get prepared to ask yourself, "What will I have to give up to get everything I want?"

The answer: a lot.

The reason you're making a movie is not to make a ton of money from it; the reason is to make the movie. While I know this sounds harsh, I don't mean it to be. In fact, I don't even like to say it. I really want you to make money, because *you need the money.* By definition, the people investing in your movie *don't* need the money. Investing in films is a crapshoot, and a film is generally not a good investment unless you're a big movie studio or a seasoned production company. Individual investors rarely get their money back, and they should make peace with that reality.

(As a side note, I implore you to only take money from investors who really can afford to lose it. Please don't take money from investors who are giving you their child's education funds or money that would be used for their house payments. The likelihood is they will never get their money back. If you take money from investors who can't afford

to lose it, and they do lose it, you will feel horrible—and you should.)

Initially, when you construct the cost budget of your movie, there will be a line item for your services as writer and/or director. (There will also be line items for the producer, for the cast, and for everybody else involved in the picture.) As the principal creator, you will find yourself in a position of working longest and hardest to make sure your movie is finished, and you'll probably toil for far less than minimum wage. You should be able to negotiate a back-end participation for yourself; however, don't expect to see any income from the back-end unless your movie is a once-in-a-lifetime, outstanding success. In most cases, the amount of money you negotiate at the beginning is all you will receive.

In addition, if the film goes over budget or you need more money later, you may find yourself in a position of having to give back some of your salary in order to get additional funds. This is another reason to make sure your first budget (the one you share with investors, the one on which you raise your financing in the first place) is accurate and comprehensive. I don't want you to have to give away your fee, because you will absolutely earn it.

So you will work for low wages to get your dream project made, and that may well be a fair trade because, after all, you're not just going to FedEx Office and putting $5 on the counter to publish a booklet of poetry: you are trying to create something that requires resources far beyond your personal bank account. When you get to the point where you can bankroll your own movies, the situation will be different, and

you will have complete control and ownership. But for now, you won't.

If other people are investing in the movie, they will form a corporation or an LLC, which will be the investment vehicle. This corporation will be the "owner" of the movie, and all revenue will flow to the corporation; that's how investors hope to get their money back.

60. THE MYTH OF FINAL CUT

OK, you won't get a ton of money.

At least you'll be able to make your movie, right? At least you'll get final cut?

Not really.

You may have heard of final cut, the magical power directors have to command, "This is what I made. Here it is. Take it. You can't do anything about it. I am the sole creator."

You may think that lots of directors in Hollywood have a final cut, but they don't. All directors, even the most prestigious directors, have certain limitations on what they can deliver as a movie. For example, they must deliver a movie that conforms to the script, is within a certain budget, has a certain minimum or maximum running time, and generally has a certain minimum and maximum rating. That doesn't sound like final cut to me; it sounds like a lot of freedom within some very specific parameters. Moreover, the directors who have even that much freedom are few; I can count them on the fingers of two hands.

Most directors do not have anything that approaches even that level of latitude. Generally financiers (or the studio) determine final cut. If the movie is produced independently and sold to a distributor, the distributor will have final cut. Make no mistake about it; you need to have distribution for your movie (unless you are distributing it yourself). The distributor will insist on the right to change

your movie in any way it deems necessary. If you do not grant that right, the distributor will walk away from the deal. So wrap your head around this now: you will not have final cut.

How do you immunize yourself against having your movie re-cut or changed? Make a good movie in the first place. Make a movie so compelling that more than one distributor will want it: then you can have discussions with the potential distributors to make sure they validate your vision and don't want to change it, or do not want to change it very much.

At the same time, when distributors get involved, they may add value and make your movie better. They might, for example, allow you extra money to reshoot a scene or add music or visual effects. Distributors' involvement is not necessarily bad. In fact, generally distributors' involvement is *beneficial* because distributors know the audience, and they will help tailor your movie to the audience.

What will you give up to get your movie made? A lot. What will you get in return? Well, my friend, you get to make your movie.

VI: INSIDE TRACK:
NOW YOU MAKE
YOUR MOVIE

The moment you've been waiting for

Why do we have to work so hard to get our movies made? Why can't we recite a magic spell that will cause our script, director, cast, and money to materialize?

Because making a great movie is even harder than putting it together. At least once, in the middle of every production I've worked on, I find myself staring ahead in a daze, sleep deprived, frustrated, uncertain about everything, and I ask myself, "Why am I putting myself through this?"

Then I remember how hard it was to get here, the immeasurable work of my fellow team members, the awful nights of despair when we thought we wouldn't make it—and I keep on keeping on.

You have worked so hard to get to this place, and it is the hard work you've already done that will keep you going.

61. THIS IS THE INSIDE TRACK WHERE YOU MAKE AND FINISH YOUR MOVIE

It's not part of this book.

Remember? I told you this is a book that teaches you *how to get your movie made*, not how to make your movie. I'm assuming you know how to make a movie and, if you don't, you're going to learn before you get going.

I just put this tip here in case you're a step-by-step person and would have thought you missed it.

You didn't. I'm glad you're paying attention.

P.S. If you want the best, most up-to-date guide on how to make a movie, get *Filmmaking in Action: Your Guide to the Skills and Craft*, a definitive new book from Bedford/ St. Martin's. I've written it with Barry Weiss and Michael Goldman. It is a giant and rather awesome book, full of technical and storytelling fundamentals, plus generous insights from famous people in our industry, and written with the full support of the Academy of Motion Picture Arts and Sciences, Directors Guild, Producers Guild, Writers Guild, American Society of Cinematographers, Visual Effects Society, and the Previsualization Society. You can get your copy and find out more about it at http:// macmillanhighered.com/filmmaking.

VII: INSIDE TRACK:
GETTING INTO FESTIVALS
WHEN YOUR MOVIE'S
READY

Sundance and beyond

Film festivals range from the well-known, like Sundance and Tribeca, to the hilariously obscure, like the International Moustache Film Festival in Portland, Maine. With so many festivals to choose from, there will definitely be at least one that will be right for your film.

This Inside Track will prepare you to navigate the film festival circuit and help you increase your chances of getting the right festival berth.

62. DO FESTIVALS MATTER?

There are more than 8,000 film festivals worldwide. What an amazing and exciting array! Obviously, you don't want to go to all of them; it's physically impossible. But you do want to get into *some* of them.

There are good reasons to submit your movie to festivals. Festivals offer terrific, avid, appreciative audiences who will respect your efforts and with whom you can freely engage. Just as importantly, at festivals you will get to meet other filmmakers. They're part of your tribe, but often members of the creative community do not get to come together as a tribe. We work alone in our studios, in our rooms, in our coffee houses, on our laptops, and we don't see one another that much: the creative process is often a solitary process. If you've just finished your movie, you will have been locked in an editing room for months, with your editor and maybe one assistant, drinking cold coffee and trying to make your deadline. It will be good to get out into the fresh air of a festival and meet other filmmakers who have just been through the same process. You'll learn from them, share stories, and develop friendships that may last a lifetime. You may even find collaborators for your future projects.

You will also get reviews. Reviews matter, and the reviews at festivals matter more because you had to get into the festival in the first place. Reviews bolster your cred-

ibility and can be added to your press pack and marketing materials when you subsequently work to sell your movie.

Finally, you should apply to festivals because getting into a festival itself is a selective process. By getting in, you show that your film has superseded others. It makes your movie more attractive to distributors and audiences.

63. SOME FESTIVALS ARE MORE THAN FESTIVALS

Getting into a festival doesn't necessarily mean your movie will get distribution. Even the most famous festivals host far more movies than are ever distributed.

That's why, among the festivals you apply to, you should target some that serve a twin function: festivals that also serve as *film markets*.

There are film markets just like there are grocery stores and new car lots. Film markets are places where people buy movies. Yes, you can buy a movie; there is a robust international trade in finished films. I began my tenure at National Geographic Films by transforming it into a company that bought completed movies. This is called *acquisitions*.

When you acquire a movie, you acquire the rights to distribute it in a certain territory, in certain media, for a certain period of time. (A *territory* is movie biz language for a country. In film-speak, Italy is a territory, France is a territory, "North America" is a territory that mysteriously includes the U.S. and Canada but not Mexico, and so on. Vestiges of colonialism? You bet.)

You don't need to know more about the contractual details right now—if you're selling a movie in a film market, you will have a sales representative, and perhaps an attorney, who will work through all the details.

The major film market festivals are Sundance, Toronto, Telluride, Berlin, Cannes, and Venice. Telluride is especially

good for documentaries. Only Cannes, Toronto, and Berlin have official markets, with convention areas where buyers and sellers meet. The other festivals are unofficial markets, where buyers and sellers do business in restaurants, bars, and hotel suites.

Don't neglect festivals where there's an international distributor presence (some festivals in the U.S. and more festivals internationally). Remember: only 30% to 40% of the revenue on most movies comes from the U.S. and Canada. The rest comes from overseas.

64. HOW YOU GET INTO A FESTIVAL

Follow the rules.

You'd be amazed at how many people have come to me crestfallen because they've missed a deadline that passed a week ago. The best resources for learning festival rules and managing your festival submissions are the websites withoutabox.com and filmfreeway.com. They have everything you need and will make your process as simple as possible.

Festival applications cost money, and you will have a limited festival application budget. Make your applications wisely; you will not be able to make an infinite number of them.

Make sure your film fits the parameters of the festival. For example, if the festival only shows movies made on mobile phones and your film wasn't, don't bother to apply. If the festival is primarily for documentaries and your movie is a narrative feature, scratch it. If the festival is for filmmakers who are native to a region and you come from somewhere else, move on.

Make sure you can meet the deadline and can deliver the materials to the festival selection committee *in the manner that it has requested them*. Every festival will have specific ways in which it wishes to receive your materials. Some will want you to upload something to a website. Others will want to see a DVD. Some festivals will look at a rough cut of your movie; others won't.

Make sure you can deliver what festivals ask for in a time frame that makes sense for your film. If not, let it go. Don't compromise the quality of your work just to meet a deadline; there will always be another opportunity.

Once you've applied, try to make relationships. In addition to following the formal rules, there is the informal process of getting into some festivals. People who curate festivals, people on the selection committees, will tell you that relationships don't matter, that all they look at are the films. They're right, and they're also wrong.

Sometimes filmmakers with a great movie and no preexisting relationship with festival selection committees get their movies into festivals and become the stars. And sometimes filmmakers who have relationships with selection committee members, who have spent a lot of time and attention developing those relationships, get their movies into festivals when other movies are better or at least as good.

How to start? Perhaps you can meet a festival representative in person, or place a call and try to talk to someone on the selection committee. I don't advise trying to cajole this person into selecting your film, but I *do* advise developing a relationship, learning about what he or she is looking for, and getting any tips or pointers you can. If your movie is in an incomplete state and you need to provide some background explanation, do it in a personal way so festival representatives have a relationship with you.

Remember: the festival representatives' job is to find exciting new films by exciting new filmmakers. They *want* the relationship with you, as long as you don't transgress the boundaries of ethics or good taste. It is

completely appropriate for you to show an interest in what they're doing—because you generally *are* interested. Your interest in them may be reciprocated by their interest in you.

If you are working with an agent or a producer's rep, he or she will help you in the festival labyrinth and pave the way for some of your festival relationships.

VIII: INSIDE TRACK:
SELLING AT FESTIVALS

Can you make a deal here?

When you get into a festival, you can earn more than accolades and audience adulation—you may even be able to sell your film for distribution.

This Inside Track gives you the key tips for maximizing opportunities to sell your movie at a festival, especially if there's a film market going on at the same time.

65. **LEAP INTO ACTION**

As soon as you're notified that you've gotten into a festival, get into gear. You have less time than you think. Some festivals do not announce their acceptances until 30 days before they begin, so the run-up to a festival berth needs to be a period of intense focus and preparation.

You're going to have a limited number of shots at festivals; the first one may well be the most important. Your first festival is the first opportunity audiences, critics, and potential distributors will have to see your movie. You never get a second chance to make a first impression.

66. GET YOUR MATERIALS READY

Once you get into a festival, make sure you have everything you will need to make your movie appear ready for distribution.

Distributors will ask themselves, "Can I sell this movie?" You need to provide the answer. The more convincing your answer, the more likely your film will sell.

Put on your marketing hat and go back to some of the things you learned in the earlier Inside Tracks about concept, key art, and taglines, and make sure everything works.

It's a great time to inspect your title one more time. Does it really convey the movie you've made? Is there a better title? It's now been a year since you started making your movie. Perhaps another movie has come out with a similar title. Perhaps new perspectives from the news or the zeitgeist can suggest a better title. Get your title in shape if it is not ready for prime time.

Get your website in shape, too. Every film going to a festival should have a dedicated website. I hope you registered the URL of your movie's title. If not, do it now. Register something close to the title if your title isn't available.

If you have the perfect title for your movie, but that URL is not available, do *not* change the title just because you want the URL. Find another URL that is close or suggests something like your movie. For example, Universal Pictures, which distributed the movie *Ted*, couldn't get the

URL Ted.com, so it chose Tedisreal.com. That worked well, and the wording did something else—it was a way to add some creative branding to the film. It's a far better URL than a choice like ted-themovie.com would have been.

Your editor should cut a trailer, or you may want to hire an editor who is expert in cutting trailers, because it's a somewhat different skill than cutting an entire feature-length film. There are also companies that specialize in cutting commercials and trailers, and you can look into retaining one of them.

If cutting a trailer is beyond your resources or expertise, consider a *scene trailer*. A scene trailer just shows one single, powerful scene from your movie. It should be short (no more than 2 minutes) and intriguing enough to make the audience want more. Many independent films start with scene trailers and build supporters this way. The end of your trailer, whether a scene trailer or a traditional trailer, should display the URL for your film's website.

Post your trailer on YouTube, and then embed the YouTube code onto your website. Make sure you un-tick the box on YouTube that allows it to place advertisements over your trailer, or allows it to suggest other videos after your trailer plays. You can do this by opening all the settings on your YouTube account and making sure you've been careful in your selections. You don't want to advertise someone else's movie!

On the menu bar, your website should also have:

About the Movie | Cast and Crew | Credits | Production Stills | Press Information

All these elements (apart from the trailer) go into your *media kit* (also called the *press kit*). Media kits don't need to be in physical form anymore; most people seek them online. You probably don't need to create a physical media

kit unless you have a high-profile movie and you're creating other physical marketing materials.

Having all this material on your website lets a potential distributor know you've done some heavy lifting. The production stills are especially important, because they can generate advance publicity, and you may even find the image for your one-sheet in them. In all likelihood, your distributor will re-do your materials, but you will have provided a head start. You want to make the distributor's job as easy as possible.

67. **GET YOUR REP**

If you're going to a festival to sell your movie, make sure you have competent representation. You need an experienced sales agent or a lawyer. Unless you've done these deals before yourself, don't try to do it now.

How do you find sales agents and lawyers? For sales agents, an excellent resource is the Independent Film & Television Alliance, which posts its membership directory online at http://ifta-online.org/member-directory.

In addition, study who has attended that festival in the past. Film markets regularly publish a roster of professionals in attendance. Investigate who they are and the kinds of films they have handled. Find people who have handled films similar to yours. Email or call them. Tell them your film has just been accepted into the festival and you're seeking representation. They will be only too happy to take a look at your movie; if they like it and sell it, they will collect a commission.

This is a great time to show your prospective rep how smart you are: if you followed the advice in this book, you have money in your budget to pay for marketing. You'll earn points, because an agent or lawyer knows this will strengthen their hand in potential negotiations.

Don't be disappointed if some of the representatives turn you down. Most reps are highly selective because they know they will not sell every movie in their portfolio at a

given market. For that reason, you should approach several representatives at the same time. Don't make the mistake of going one by one, because you may run out of time. Go to at least three at the same time and give them two weeks to respond. If they have not responded in two weeks, go to the next five, and so on, until you find someone who will represent your film.

68. GET SOME EARLY PRESS

It's advantageous to come into a festival with press support in hand.

Start small: blogs in your area of interest, blogs run by people in social networking groups to which you already belong, and local and micro-local media, such as your hometown newspaper—the *Downtown News* or the *Larchmont Chronicle*.

Approach the editors of these publications or blogs and tell them you're a local person or part of their social network and you've just gotten into a festival. Send them a press release and make yourself available for an interview, or offer to write a guest post for them (often these editors are hungry for free content). Most likely, you'll get at least a small paragraph somewhere.

Get as much press as you can; it builds your momentum.

69. BUT DON'T LET PEOPLE SEE IT YET

Once your film has been accepted to a festival, clamp down on screenings. You do not want to let people see your movie prematurely.

If your film has some profile and momentum, and it gets into a festival, distributors may call you and request the opportunity to see your movie early. Unless your representative convinces you otherwise, you should politely decline. Why? Because once one distributor sees your movie, it is like *all* the distributors have seen your movie; they talk amongst themselves. Even if they don't communicate directly, Distributor A will know that Distributor B has passed, and that will make Distributor A less interested in seeing your movie when it finally screens.

Instead, you want to get your potential distributors to see the movie with the festival audience, because festival audiences are the best audiences in the world.

Festival audiences are so good, in fact, that they will give you a skewed perception of your movie. They will laugh at more jokes than you put in the film. They will jump at more scares than you created. They will cry at places you never imagined even the most sensitive human could cry. That's because festival audiences are amped up on their own filmic excitement, and we love them for that!

On the one hand, don't let festival audiences make you think that your movie is better than it is. It probably still needs some work for general audiences, and I hope you

get a distributor who helps you finish your work to its maximum potential. On the other hand, festival audiences offer the perfect environment for a distributor to experience your movie, because, sitting in that audience, feeling the swell of laughter and tears, becoming involved and enwrapped in the cinema experience, the distributor will find it impossible not to be affected. Buying decisions are first and foremost emotional decisions.

This seems to contradict what I said earlier, about distributors following a rational financial analysis process. What I said about rational financials still holds, but first there must be an emotional connection; the distributor must fall in love with your movie. Sitting in the midst of a festival audience is the perfect place for a distributor to fall in love.

70. **REACH OUT TO YOUR PREFERRED DISTRIBUTORS**

Once you've gotten into a festival, reach out to the distribution companies you would like to work with. This isn't presumptuous; they will be flattered. While your representative may reach out too, it's especially nice if you do it yourself.

Most filmmakers don't take this step. They're missing an opportunity to begin a relationship with a potentially important partner—important for this one movie and for other movies throughout their careers. Distributors like to be noticed and appreciate being treated as collaborative partners. By personally reaching out to a distributor, you demonstrate your understanding of this unspoken protocol and increase the likelihood the distributor will show up at your festival screening.

71. **GET THEM TO THE SCREENING**

In the week prior to the screening, reach out to the distributors again and remind them of your screening day and time. Send a short reminder email on the morning of your screening.

Distributors at film markets get crazy busy. Movies crop up that they haven't expected, and special screenings suddenly demand their attention. You want to make sure your distributors get into the room when your movie screens. Of course, there may be a second screening, but it's the first screening that has the most buzz and enthusiasm.

Ideally, you will get all your potential distributors into that first screening together. They will see one another in the auditorium. They will know they're all potential buyers, and their competitive juices will begin to flow. If your movie is good, this will be your perfect selling situation.

72. GET THE PRESS THERE

Even while you are reaching out to potential distributors, you should also reach out to larger press, the press that will be in town covering and reviewing the festival. Begin contacting press as soon as you get into the festival, and continue your outreach throughout the festival experience. It may be wise to hire a publicist or a press representative to do this for you, or with you.

Press may review your movie, and reviews at festivals are taken seriously by potential distributors. Frequently, distributors will be on the fence about whether or not to buy a movie and then, when a favorable review from a major publication is posted online, they will pounce. Distributors view these reviews as bellwethers, predictors of what the reviews will likely be in national press when your movie is released.

73. **FOLLOW THROUGH**

After the screening, you or your representative should follow up with all the press people and distributors in attendance. See what they thought, and try to gauge their potential interest. If some distributors or press people didn't make it to the first screening, redouble your efforts to get them to the second screening, if there is one.

Tell those errant fools how excellently your movie was received, and that they'd better get in gear and come to the next screening or they'll be missing something wonderful.

Say it politely, of course.

IX: INSIDE TRACK:
SELLING EVERYWHERE ELSE FOR THEATRICAL DISTRIBUTION

More places to make deals

So you didn't get into Sundance.

So what?

Most independent movies that get distribution didn't get into Sundance either. In fact, most independent movies that get distribution didn't get into a major festival at all; the filmmakers behind these films worked their way up through a winnowing process of screenings, distribution relationships, press acclaim, haggling, and luck.

This Inside Track will prepare you for all that.

74. MOST SALES HAPPEN THIS WAY

As you've just learned, festival exposure can be great. However, contrary to popular wisdom, it is not a prerequisite for getting distribution. Sometimes a film will be finished, and the filmmakers don't want to wait for the festival cycle, what with its submission process, waiting times, and low rates of acceptance. Sometimes a perfect opportunity arrives with the perfect distributor, and it would be crazy not to grab it.

Of the 500 or so independent movies that get a theatrical release each year, most did not have festival screenings. When you add in all the films that get digital-only releases, the number is far, far greater.

You don't need a festival to get a distribution deal. You need a good movie with an identifiable audience, and a lot of hard work.

75. GET A REPRESENTATIVE IF YOU CAN

If you can get a selling agent or an attorney to represent your film, do so.

Of course, if you didn't get into a major festival, this may not be easy. Selling agents and attorneys who represent films are inundated with requests, but don't let that stop you. Just because there's a lot of competition in the field doesn't mean you shouldn't try. After all, you got this far. You got your movie made; that's more than most people can say. You may well be able to go to the next step.

Email or call representatives, tell them about your movie, and ask them to take a look at it. If you have a website, you can suggest they look at the trailer and then offer them a screener or a private Vimeo link.

By the way, you should have a website before you do this. If you've been reading, you know that already.

Notice I said *screener* or *private Vimeo link*. Representatives rarely get out of their offices to go to a screening room. You may want them to see the movie on the big screen, but usually they don't have time.

A DVD copy is called a *screener*. Vimeo is an Internet service, similar to YouTube, except that it is higher quality, has no advertisements, and allows you to create private or password-required links so you can control who sees your work.

Agents are used to seeing movies this way. If you demand they see your movie in a cinema, you'll show your

ignorance—these people may watch between three and ten movies a day. They simply cannot attend actual screenings; they have to look at films in a more efficient way.

Your screener DVD should have some identifying information "burned" into it. This means the movie image will have a name or number superimposed over it in a corner of the screen. For example, you might burn in the representative's initials. (A DVD duplication company and some software programs can do this for you.) While this will not prevent anyone from copying your movie, it will be a deterrent. If you're using Vimeo or a web link to share your film, it is not customary to do a burn-in.

76. IF YOU CAN'T GET A REPRESENTATIVE . . .

Take the bull by the horns and reach out to distributors yourself.

Have your materials ready: screeners, full press kit, robust website, and a trailer with all the bells and whistles. Call distributors and tell them you have a movie you'd like them to see. If your film is really high profile, with a star cast, you should try to get distributors to a physical screening.

This is different from the approach with agents or other representatives. Distributors may prefer to see your movie on a screener or web link, but if there is a screening that's going to take place with an audience, try to get them there: they will feel the audience's energy and may respond to it.

77. YOU HAVE TO SEE IT WITH AN AUDIENCE FIRST

Never, ever show a movie to a distributor with a live audience if you are not *absolutely certain how the audience will react.*

If you have a comedy, you'd better make sure the audience will laugh until they hyperventilate. If you have a thriller, you'd better make sure nobody will get up and go to the bathroom at the 45-minute mark. The only way you can know is by having done it before.

That's right: you have to do audience screenings *before* you let any distributors see your movie. This is standard filmmaking practice. Once you have finished your film (or think you've finished it), show it to the ultimate buyers: the ticket purchasers, the audience. Do some test screenings on your own.

Studios do this all the time. You may even have been to a studio preview where you were recruited outside of a theater. Afterwards, you were asked to fill out some survey cards or even participate in a focus group.

You should do the same thing with your film. Openly, without your ego in the way, *feel* how the audience reacts during the screening, and then *listen* to the discussion afterward.

You should not lead the discussion yourself. For the audience to give valid reactions, they must believe they

are talking to someone not affiliated with the movie. In a neutral environment, the audience can openly discuss what was interesting or not, what was boring or exciting, who they cared about, and what story points they did not understand. This last point may be the most important. Often, with the first cut, the audience simply does not understand important story points, which makes them lose interest and diminishes the emotional impact of the movie. A few editorial fixes, and perhaps some additional dialogue, usually clear up errant story points and improve audience reaction.

Once you know how an audience is going to respond to your movie, *then* you can invite distributors to see it. It's especially tantalizing if you can invite distributors to a screening that is happening soon after you make your initial contact; you will spur the distributor's competitive instincts. If they feel they are the only distributor going to the screening because they've been particularly aggressive, you will stand a better chance of getting them there.

78. IF YOU CAN'T GET A DISTRIBUTOR TO AN AUDIENCE SCREENING

Sometimes—often—distributors won't come to an audience screening. Sometimes you can't do an audience screening, for practical or financial reasons. What should you do then?

Concentrate the timing. Make sure all the potential distributors see your film within a tight time frame.

Whether you take a print of the film to the distributors' screening room and run it for them there (this is obviously preferable), or you send it to them on a screener or a web link, you will want to hit all the distributors within one or two weeks. The reason for this? Distributors talk to one another and will know what others have done. Then, you know what happens: if one distributor passes, other distributors will be less interested in seeing your movie.

You want to control that flow of information. You want to make sure each distributor feels in a prime position to see this movie before the others and therefore has the best shot at making a deal if your movie could be the next big indie hit.

79. **SHOULD YOU SHOW A DISTRIBUTOR AN UNFINISHED FILM?**

It depends on the distributor.

Sometimes distributors will ask to see a movie early when it's in rough cut form. It's not always a good idea to do this, unless you have already developed a relationship with the specific distribution executive who makes this request. Many distributors, even though they're film professionals, don't have the imagination to foresee how a film will finish.

On the other hand, some really do. An imaginative distributor, involved early in the process, can be a terrific partner and can help you shape your movie to its fullest advantage.

How can you tell which kind of distributor you're talking to—one who understands how to watch an unfinished film or one who doesn't? You can tell by asking this question: "I have a rough cut now, and I'll have a finished cut in four weeks. Would you prefer to see it now or wait?"

Most distributors would rather wait.

A few will ask to see your movie early. Ask them how they evaluate unfinished work. If they have a history of seeing movies early and helping filmmakers complete them well, you are probably in good hands.

80. **WHAT TO SHOW POTENTIAL DISTRIBUTORS**

You already know you should have a robust website, a full media kit, and some press coverage if you can get it before you contact any distributor. Having these materials in hand shows the distributor that you're a professional, that you understand the work that will need to be done to sell your movie, and that you are taking responsibility for helping to handle it.

Early in the process, you may wish to entice distributors by showing them selects of your movie. You already learned about selects—a reel that's 10 to 20 minutes, with the best photographic elements, visual imagery, performances, action sequences, and funny or dramatic scenes. Distributors generally won't make a deal based on your selects reel, but it's a great technique to help build a relationship with them.

You can show the selects by bringing them over on your laptop or tablet to their office. Don't leave the selects with the distributors, because you don't know where or how they might be passed around. This early, low-key relationship building may entice distributors to come to the first screening when your film's available.

81. KNOW HOW MUCH YOU NEED

If you followed all the preceding steps and you've made a movie with a great concept and great actors, and you've made sure the audience responds to it well, you may get to this point: negotiating a deal.

When this happens (and I hope it happens for you), it's important to have a reasonable expectation of what that deal will be. Too often, filmmakers or first-time investors blow deals because they ask for too much or for inappropriate conditions. A lawyer or representative who is seasoned in the business can help guide you with realistic expectations.

"What you need" is different from what you want. You *want* $20 million! However, you may only *need* $50,000 to make your investors whole. In this example, have "$50,000" in the back of your mind, and try to make sure you get at least that much. Unless there's a lot of competition for your movie, you probably won't get more. Knowing what you *need* will give you a benchmark and will keep your negotiations rational. Moreover, you will be able to make your "ask" with absolute, quiet conviction: you will not be subserviently requesting a sale—you will be stating what you need.

X: INSIDE TRACK:
SELLING FOR
NON-THEATRICAL
DISTRIBUTION

The screens that make the most money

What you've learned thus far about selling to theatrical distributors also applies to when you sell for non-theatrical, or digital, distribution. And you will need to add to these skills. Non-theatrical distribution is far more data driven, and you'll be expected to know your audience even more granularly, and also to be able to bring them to the party.

This Inside Track will help you invite everyone to your movie—digital distributors and download customers alike.

82. WHAT'S NON-THEATRICAL?

The holy grail for most filmmakers is theatrical distribution—screenings in cinemas before thousands of adoring fans. Unfortunately, there are far more films made than there are available screens to show them on, but if your movie doesn't make it to the big screen, all is not lost.

There's always non-theatrical.

Non-theatrical is every *other* way you can see a movie: home video, home entertainment, and any kind of digital distribution. Non-theatrical includes DVDs; television and cable; video on demand (VOD), which includes subscription video on demand (SVOD) and ad-supported video on demand (AVOD); iTunes; Netflix; Amazon Prime; Hulu; and Hulu Plus.

Most movies actually get more audience eyeballs in their non-theatrical runs than they do on cinema screens. Perhaps there are two holy grails.

83. WHY ARE YOU DOING THIS?

When it comes to non-theatrical distribution, you need to pick one of two strategies.

The first: you want to get your movie out as soon as possible, make a splash, and try for those audience eyeballs.

The second: you want to make as much money as possible, and you're willing to sacrifice speed for dollars.

If you're pursuing the first strategy, you will make direct submissions to content distributors like Hulu.

On the other hand, if money is your main objective, you'll want to seek out an aggregator.

84. AGGREGATORS

An aggregator is a company that takes some or all of your rights and sells them for you. Aggregators come in three flavors:

1. Studio aggregators, like Cinedigm, Magnolia Pictures, Film Buff, and Anchor Bay (which is owned by Starz and the Weinstein Company). These are full-service companies that take all your rights and will handle distribution in all forms—theatrical (if it is appropriate), home video, electronic rental, VOD, television, licensing, airplanes, and even steamships. (Yes, we still call cruise lines "steamships." For all its new technology, the entertainment industry retains some deliciously quaint aspects.)

2. Digital aggregators, like Gravitas (http://www.gravitasventures.com/), Orchard (http://www.theorchard.com/), and Amplify (http://amplifyreleasing.com/). They take all digital rights and sell to iTunes, Netflix, Hulu, other VOD platforms, and cable companies like Comcast. Gravitas is a best-in-class marketing partner, because it shares promotional guidelines with its filmmakers to maximize marketing and social media efforts.

3. Independent aggregators, like Virgil Films (www.virgilfilmsent.com), Distribber (www.distribber.com), and Premiere Digital Services (http://www.premieredigital.net). Independent aggregators will parse out rights; they work with filmmakers or copyright holders, figure out what rights are available and are most likely to sell, and handle only those areas. (What rights are most likely to sell? That differs, film by film.)

85. MATERIALS

At this point, you should already have most of your materials in place. To submit to aggregators (or directly to nontheatrical distributors), you'll need:

- DVD screeners (which probably won't be returned)
- Vimeo private web link
- Website
- Trailer
- Short synopsis (185 characters)
- Long synopsis (944 characters)
- Cast in billing order
- Director name and short bio
- Running time
- Genre
- Release strategy, with well-thought-through specifics
- Marketing strategy, with more well-thought-through specifics; use the evidence-gathering techniques you learned in the first chapters of this book to inform your release and marketing strategies.

86. DIRECT SUBMISSIONS

Maybe you don't want to go to an aggregator, or aggregators have turned you down. You can still approach non-theatrical distributors directly.

Some are easier to approach than others. Netflix makes it quite difficult, because they far prefer to work with distributors, and Hulu has recently started doing so as well. However, some smaller distributors still take direct submissions.

No matter whom you're submitting to, take the time to study your potential buyers. Look at the categories or genres (or *verticals*) they have, and make sure your film fits into one or more of them. See what they're promoting and how they promote.

Then, follow their rules and approach them respectfully. If you leave a message and say, "Hey, call me back," they won't. If you send an email declaring "This is the hottest movie on the planet!" you won't get a response.

Instead, follow their guidelines and give them succinct answers to the questions they ask. Show you're prepared, show you're serious, and show you're ready to keep marketing and promoting your movie if they take it.

Most of these companies won't start by looking at your movie, because they have very few people vetting thousands of submissions (one major company has only one single person with this gigantic responsibility). First, they'll scan your materials to understand your project and strategy for selling; if your materials make sense and fit their needs, *then* they'll look at your movie.

87. KNOW YOUR WINDOWS

In movie-land, windows aren't made of glass; in fact, the concept of windows can feel pretty opaque.

You already know what windows are, without being able to call them by name. Windows are the sequential delivery of movies across different platforms. You know, for example, that movies appear on cinema screens before they show on television. That's because the "theatrical window" comes before the "TV window."

Sometimes filmmakers mess up their distribution possibilities by selling partial rights, which may work against a larger windowing sequence. For example, if you decide to sell only SVOD rights and the SVOD distributor releases your movie immediately, you've missed your chance for other forms of distribution.

The window sequence is in a state of flux, and distributors will be experimenting with different window strategies for the rest of this decade. It may seem like no two independent films follow exactly the same windowing strategy. Therefore, while you shouldn't take the sequence below as definitive, it will give you a basic primer on how windows work in some cases, and it will give you a handle on the vocabulary you'll need.

Windows

1. Awareness. This begins 90 days before the VOD/cable or theatrical date; it's the launch

of your marketing campaign. You'll start by seeding your trailer with a trailer service, or on YouTube or Hulu. Don't put your final trailer up until you have a distribution strategy— otherwise, you'll frustrate your distributor's plans for building audience anticipation in a systematic way.

2. Pre-theatrical. Some indie movies get released on VOD before they can be seen in theaters. How long before? It varies. Many movies that use this strategy are available 1 to 3 weeks before their theatrical release; some have an "ultra-pre-theatrical" release 30 days in advance.

3. Theatrical window. Typically, the theatrical window lasts 3 or 4 weeks. It is often combined with . . .

4. Day and date window. This means the film opens simultaneously on VOD and in theaters (on the same day and the same date). The day and date window can last for 50 to 60 days.

5. After-theatrical pay-TV window. Some movies, particularly studio films, become available on pay TV 90 days after their theatrical release. For indie movies, it can happen much quicker—before theatrical release, day and date, or one day after.

6. Electronic sell-through (EST). These are transactions, and this is called the transactional window. iTunes falls in this category. Generally, the window begins 30

days after initial theatrical release, or 30 days after the movie ends its theatrical release.

7. The subscription video-on-demand (SVOD) window begins 50 days after theatrical release.

8. The free video-on-demand (VOD) window begins 180 days to 1 year after the SVOD window for indie films; for studio movies it is much longer—up to 6 years.

Distribution companies are experimenting with different window strategies, and these experiments will continue. The pre-theatrical release and day and date strategies are paying off nicely. IFC releases its films for pay-per-view on its cable channel three weeks before their theatrical release, and its movies often open in theaters having already grossed $1 million. Roadside Attractions set a record in 2012 by opening *Arbitrage* day and date. *Arbitrage* grossed close to $12 million on VOD, and $7.9 million theatrically.

There are two morals here. First, if you want to partner with a distributor, don't sell off part of the rights or one of the windows prematurely—you might get in the way of the perfect distribution strategy. Second, remember you are here to make enough money to pay the rent and have a shot at making your next movie, so don't be a prima donna about releasing first on theater screens or worrying about how many screens you get. Just getting your movie in front of your audience, in any way, in any window, in any order, is a giant win.

88. DELIVER TO THEIR SPECS

At last, you've made your deal, and you have a non-theatrical distributor or aggregator ready to take your film.

Now, you have to deliver your movie—you have to give it to your buyer so the company can distribute it.

Delivery has two parts—physical and legal. In both cases, I recommend you work with professionals to help you, because delivery can be cumbersome and highly technical.

PHYSICAL DELIVERY involves giving the distributor everything it will need to provide audiences with physical or digital access to your film. Because of the proliferation of devices—distributors must be able to send your movie to iPhones, Android phones, Wii, PlayStation, tablets, laptops, TVs, and more—this gets complicated very fast. Apple's and Hulu's delivery requirements run close to 50 single-spaced pages each! Work with a post-production facility or an aggregator to get this done. It is best to talk with an experienced post-production facility *before* you start making your movie, to make sure you capture everything you need. Sometimes, distribution deals fall apart because it would be too expensive to comply with the delivery requirements; avoid this with advance planning.

LEGAL DELIVERY means you must show you have the right to sell your movie. This includes signed agreements with your cast, crew, screenwriter, producers, editor, composer, and anyone else who worked on your movie; it also includes agreements to use the music and display any iden-

tifiable products, brands, or copyrighted works (such as sports team jerseys or works of art). The distributor's legal counsel will inspect these agreements, plus any agreements for underlying rights, in case your story is based on a book or true-life story. Taken together, all these rights are called *chain-of-title*, and the chain must be unbroken. If there are any breaks in the chain, such as time lapses or incomplete or unsigned documents, you'll have to fix them before the distributor will accept delivery.

XI. INSIDE TRACK:
FREE RANGE DISTRIBUTION
The new frontier

Once upon a time, about a hundred years ago, a bunch of Eastern European immigrants moved to California and started the motion picture studio system. There were no rules, film was in its infancy, and, by making it up as they went along, these people started a revolution in entertainment and narrative creativity that transformed the world.

A similar revolution is taking place right now. The main characters of this uprising are filmmakers like you, who are maintaining control of their work and finding ways to make money in the process. In establishing this new frontier in distribution strategies, you are also shaping the future for filmmakers who will come after you, just as the first studio heads did a century ago.

In this Inside Track, you will learn about the opportunities in this new frontier. Let's call this frontier Free Range Distribution, which captures the energy and Wild West experience you'll find here. (I learned this term from my friends at Seed & Spark, an organization that supports and facilitates independent filmmaking.)

89. WHAT ARE FREE RANGE DISTRIBUTION PLATFORMS, AND HOW DO THEY WORK?

Free Range Distribution platforms are websites that make it possible for you to sell or rent your movie. In a digital setting, a "sale" can be defined as a download that the customer can keep forever, and a "rental" is a streaming or viewing opportunity that expires within a certain period of time, usually 24 to 72 hours. Sale prices are typically higher than rental prices.

These distribution platforms go well beyond the monetization strategies of more basic sites like YouTube, where interaction is limited to advertising or requesting a donation. Instead, these platforms allow you to have a direct, transactional relationship with individual audience members.

Some Free Range Distribution sites are open to everyone, such as Vimeo, which allows you to upload and sell your movie as long as you subscribe to its Pro service. Other ones are more selective and require a submissions and acceptance process. I prefer these selective platforms because there are fewer movies on them, and their curation procedure establishes a certain level of quality. At the same time, they charge more for their services, through either a setup fee or a share of revenue.

If you're interested in exploring the Free Range Distribution option, you need to do your homework. There are many Free Range Distribution platforms available (some

are listed in the Essential Resources section of this book), and because this is an emerging and fluid marketplace, their terms and offerings change frequently. Look for a platform that has been successful for films similar to yours and that has the features most important to you.

If you select a platform that has a submissions procedure, study it carefully and make sure you have all your materials in order. Often, staff members are available by email or phone to help guide you through the process, and to answer questions as you determine if this is the right platform for you.

It's a good idea to be in touch with your potential Free Range distributors early on in your filmmaking journey, even before your movie is finished. You'll learn what is possible and what is not, and it will be just one more step in planning your release strategy well before you premiere your film—which is exactly what the big studios do.

90. YOU CAN KEEP YOUR RIGHTS

This great revolution in filmmakers' favor has nothing to do with technology—it is all about rights ownership. You are selling some or all of your rights when you make a deal with:

- A theatrical distributor
- An international distributor of any kind
- An aggregator
- A digital distributor (such as Netflix)

This usually works in your favor, because you probably don't have access to large audiences and distribution pipelines yourself. You made your movie with the hope that lots of people would see it, and you will do whatever it takes to find an audience for your work.

However, in some cases you may want to keep all the rights to your movie. You might want this because you can't make a distribution deal, or you might prefer this because you believe you will make more money by keeping your rights and selling your film yourself. A new breed of technology platforms now exists to make this much easier for you, as long as you have been strategic in your thinking and have the resources and determination to use them well.

91. **WHAT RIGHTS ARE THERE?**

The idea of keeping all your rights may sound exciting to you; in order to keep them, though, you need to know what you have.

Here are the main rights that can be sold, licensed, or kept when you make a movie:

- Theatrical exhibition
- Pay-per-view
- Packaged goods (DVDs)
- Pay television
- Free television
- Airlines
- Cruise ships

In addition, all these rights are available worldwide, and you can sell, license, or handle them yourself territory by territory.

You can still pursue Free Range Distribution even if you have already sold some of your rights—it is possible to just "free range" the rights you still possess. That's why you want to make sure an attorney looks at any contract you consider. The attorney will make sure that any rights are detailed with great specificity, so you know precisely what you are selling, and are quite clear about what you are keeping.

92. **KNOW YOUR RIGHTS**

Let's say you're entering into negotiations with a distributor. The distributor will begin by asking for everything. That's not because distributors are greedy by nature; it's just the way business is done. It's very likely your distributor will assume you don't know enough about the business to understand rights, and to try to keep some for yourself. This is another reason to have a good lawyer by your side!

In your negotiations, you can ask to keep certain rights. For example, many independent filmmakers successfully retain the right to sell their films on their own websites. But if you don't ask for it and don't get it in writing in your contract, then you won't have it.

Similarly, you might want to retain the right to sell physical DVDs. Or to host your own theatrical screenings. Or to handle the rights yourself in certain territories— which may be important if the distributor isn't equipped to service your movie everywhere in the world.

Clip rights is the right to use short clips of your movie. Most distributors don't care about these, and if you ask for them, you will probably be able to keep clip rights. This will allow you to use clips of your movie on your own promotional reel or on YouTube, or even to make mash-ups of your work, including your own movie clips, and collect some advertising revenue while doing so.

Part of knowing your rights is knowing you have full and complete chain-of-title. As you learned in Tip 88, chain-

of-title is an essential part of finishing your movie, and one which often gets complicated for independent filmmakers who have tried to make their movie on the cheap without good legal counsel. You'll need complete chain-of-title to make a distribution deal, and you'll need it if you plan to monetize your movie yourself. Otherwise, someone who worked on the film, or who made a creative contribution to the film, may sue you or try to stop you from distributing the movie.

If you're going to pursue Free Range Distribution, make sure you dot all your i's and cross all your t's in your legal documentation before you begin; it will be much harder, and more expensive, if you try to clean it up afterward.

93. INTEGRATE EVERYTHING

A filmmaker recently contacted me to ask if I could help him sell his movie. I looked at the film, and, because it was good, I told him I'd be happy to do what I could.

"Have any distributors seen it yet?" I asked.

"No," he said, and I breathed a sigh of relief. It's always an uphill battle when several companies have already seen and passed on a project. In general, it's better, and easier, to share something that hasn't been seen before.

Then the filmmaker added, offhandedly, "But it's been selling pretty well on my website."

Yikes! That's the kiss of death if you want to make a distribution deal. The filmmaker should have stopped to consider this question: Why would Hulu or iTunes take a movie and try to sell it, if it has already been available somewhere else?

When you're planning your movie, you should build your distribution plan in conjunction with your production plan. Consider all the possibilities and start determining all the screens on which you may wish to share your film, the sequencing of when your film will be available on which screen, and where you will need partners (like a theatrical distributor or a digital distributor) and where you will do it yourself. Don't divorce theatrical, digital, and physical distribution from each other; they all need to work together.

Your goal is to get your movie in front of as many peo-

ple as possible. Even though I love the full cinema experience and want audiences to see my movies in their full, wide-screen glory, I would rather people see them somewhere else than nowhere at all. Therefore, I have come to believe that as filmmakers, we should make our films available to audiences via any screen or device, and in any way and at any time they want to view them.

At the same time, sometimes you will want to sequence when and where the film will be available—for example, if you want to qualify for an Academy Award, you must have a theatrical run first and hold off on any other form of distribution for a specified number of days. (The Academy changes its rules each year, and they are different for documentaries and narrative features. To make sure you don't make an inadvertent eligibility error, check the rules yourself at http://www.oscars.org/awards/academyawards/rules/.)

And don't disregard physical merchandise. Conventional wisdom holds that DVDs are passé, but in this case conventional wisdom is wrong. Many independent films sell quite a lot of DVDs, especially when they appeal to special-interest groups or have an educational component to them. Approximately $18 billion worth of DVDs are sold in the United States every year; that doesn't sound passé to me.

94. MARKETING IS YOUR JOB

A major theme of this book is that you must be your own marketing department. For any creative entrepreneur, in any field, this job requirement is the most important and the most uncomfortable.

Let's look at discomfort and importance.

For creative people, those of us who work primarily alone in coffee shops or studios, it is truly difficult to step into the public sphere and trumpet their own stuff. This is true for filmmakers as well, even though there's a lot of social activity involved in on-set camaraderie. When your movie's done, you'll probably feel the film will speak for itself.

Newsflash: it won't. It's *your* job to speak up for it. You must demonstrate to the world how important your film is, and you do this by talking about it, in every medium, at every chance you get.

If you choose Free Range Distribution, marketing is 100% a requirement, and you must build out and execute your own marketing plan. Movie tickets—or downloads—are not going to sell themselves. You must bring the audience to your film, hold their hands, entice and encourage them, and, finally, get their money.

Fortunately, as an engaged reader of this book, you have probably already been following the steps, and you will be prepared because . . .

- You know what your film is about.
- You know who your audience is with great specificity—your audience is a clear-cut, distinct niche, not a general demographic.
- You know the size and duration of your social media following (and the social media following of your actors and creative team), and you have been building it up over the past year, so you are ready for this moment.
- You did your crowdfunding campaign, maintained a strong relationship with the contributors (and the people who peeked but did not contribute), and you are ready to turn them into your core advocates.

You did do all these things, right? If not, get busy.

Congratulations! You are now the CMO of your very own film company!

95. **FOUR-WALLING**

Distributing your movie yourself and keeping your rights does not mean you have to forgo a theatrical release. If no theatrical distributor wants to take you on, consider four-walling.

Four-walling involves renting a theater and hosting the screening yourself. On a weekday, when movie theaters are 90% empty, you can often rent a theater for $200 to $500, and you get to keep the money from tickets sold. Not a bad investment, if you promote the movie to your friends and social networks.

If you create the right buzz and do only one screening, your screening has a good chance of selling out, which means you will probably get back all the money you spent four-walling the theater *plus* have an amazingly good time. If you get this kind of excitement going, it's a good time to reach out to potential distributors again and invite them to your screening. Not only will they be impressed by your entrepreneurship, but they'll also be fired up by your enthusiastic audience, and you may get an offer at the end of the evening.

A variation of pure four-walling is using a service like Tugg (http://www.tugg.com/). With Tugg, and other emerging services like it, audience members can sign up and prepay to watch your film in a theater. When your film hits critical mass, Tugg will book the theater and arrange the screening. A number of smaller distribution companies are now using Tugg as a marketing tool to create buzz and audience awareness. You can use it, too.

96. **WHAT TO LOOK FOR IN A FREE RANGE DISTRIBUTION PLATFORM**

Every film, filmmaker, financier, and audience has different needs, and you should select a distribution platform to fit your particular project. As you're evaluating Free Range Distribution platforms, here are eight important questions to ask:

1. **How much will it cost?** Is there a setup fee? A submission fee? If the platform hosts your movie, what percentage of the revenue will it take?

2. **Is it exclusive?** Some platforms require an exclusive commitment, meaning you cannot sell or distribute your film anywhere else. Others are non-exclusive, meaning you can sell your film anywhere else and it won't be a problem.

3. **Does the player work everywhere?** All platforms will say their video player works everywhere, but does it really? You need to test it yourself. Do this by trying to watch a movie from the platform in every major browser (Firefox, Safari, Chrome, and Explorer), on a Mac and a PC, on an iPad and an Android

tablet, and on an iPhone and an Android phone. That may seem like a lot of work, but you'd rather be safe than sorry, and it would be disappointing if your movie couldn't play on any device an audience member has.

4. **Does the player travel?** In other words, can you embed the video player onto your own website and blogs, and those of your friends, or does the consumer have to go to the platform's website in order to buy and watch your movie?

5. **Can you have affiliates?** An affiliate is someone who helps you sell your movie, in exchange for receiving a percentage of each sale. This financial incentive motivates the affiliate to sell for you. Good platforms allow you to have affiliates and manage your relationship with them.

6. **Can you control the financial terms?** Can you set your own price both for sale and rental? Can you change the price whenever you want? Can you set the percentage you'll share with an affiliate? Can you give a different percentage to different affiliates?

8. **Does it have an easy dashboard?** Most platforms have a great feature that allows you password-protected access to a filmmakers' dashboard, from which you can control all aspects of your transactions. Take a look at the back-end of the platform you're considering. Is the dashboard simple to understand and

easy to operate, and does it give you all the information and control you need?

9. **Is there real-time information?** With Internet analytics being what they are, there's no reason you should not be able to see information in real time—how many people have bought your film, how many have browsed it, and even how many are watching it right now. Real-time analytics are the secret power of large companies like Netflix, and you can use them as well, to adjust your marketing strategy and emphasize approaches that will attract the greatest number of paying customers.

97. WHAT YOU'LL NEED

As you are now the CMO of your own film company, you'll
need to make sure you have all of the following before you
begin employing Free Range Distribution:

- All chain-of-title and legal documentation
 fully completed and signed by everyone who
 needs to sign. You should keep physical, hard
 copies in a safe place, and also a scanned set
 of all documents in a file on your backup
 drives.
- All picture and sound elements of your movie,
 fully completed, and fully encoded with the
 relevant metadata. Different distributors have
 different requirements or recommendations
 for metadata; double-check what your
 platform needs.
- Key art. A great movie poster definitely helps
 sell your movie. In the digital ecosystem, your
 key art has to sell itself at merely thumbnail
 size. If you are not an experienced movie
 poster designer, hire someone who is—it will
 make a world of difference.
- A killer trailer. Hire a pro to do this, too.
 Editing a trailer is different from editing
 a whole movie and requires specialized
 experience and skills.

- Bonus content for use in marketing and also to share with your affiliates, so they can use it to sell their audiences, too.
- A database of your affiliates and potential affiliates.
- A database of your audience members and fans, including their preferred mode of communications, and a way of communicating with them.
- A written, well-planned release strategy, with a timeline and goals for you and your affiliates.

98. WHAT'S BEEN WORKING

As you know by now, comps are great research tools and will afford you the chance to make decisions based on evidence, instead of hopes and dreams.

By studying the comps in Free Range Distribution, three clear best practices emerge:

1. Keep your digital rights if you can.

2. Know your niche.

3. Own your followers.

Filmmakers who have successfully distributed content do all three of these. Here are some examples of people who have successfully navigated the exciting, at times unpredictable, landscape of Free Range Distribution:

Champion athlete Diana Nyad completed her historic Cuba-to-Florida swim on September 2, 2013, at the age of 64. This was her fifth attempt, and over the course of her career, which began with the Olympics and grew to include broadcast journalism, she developed a strong audience following. A documentary about her fourth attempt, *The Other Shore*, had come out earlier in 2013, and Nyad sold television rights while keeping all the digital rights herself. With renewed publicity as she finally pulled herself on the Florida coastline, and an ability to reach her fans directly, Nyad was able to mon-

etize her documentary directly with digital sales from her website.

Aquatic fans are one audience niche; UFO/alien fans, another. *Sirius*, a movie that purports to show a real alien autopsy, made Free Range Distribution history when its producers earned $250,000 over one weekend via the YEKRA platform. They did this without a theatrical release and with almost no marketing budget; their affiliates were highly motivated and sold the movie to legions of alien abduction aficionados. I can't attest to the veracity of the film, but the movie certainly achieved liftoff.

The most profitable content thus far has come in the form of comedy shows, performed by well-known comedians who have large Twitter or other social media followings. Louis C. K. prototyped this strategy when he went on the road in 2012 and used his own money to create the video of his performance, *Live at the Beacon Theater*. Instead of selling the rights, he kept them and made the show available on his website for $5 per download. In 12 days, he made more than $1 million.

Keep your rights, know your niche audience, and be able to reach them: these are the three constants for Free Range Distribution success.

99. WHAT'S NEXT FOR FREE RANGE DISTRIBUTION?

Two years ago, Free Range Distribution was just emerging and was too unstable to discuss with any certainty. Today, it's clear that the "rights revolution" is an indelible part of the filmmaking landscape and will be a significant opportunity for all content creators.

Yet Free Range Distribution is still in its formative stages, and changes undoubtedly lie ahead.

From the perspective of the distribution sites, the marketplace created by Free Range Distribution may see a shakeout sooner rather than later. There is a wide variation in quality, in terms of both technical capacity and the movies that are available on each platform. In addition, as far as I know, none of the platforms are profitable yet. The stronger ones will survive; the weak will quietly disappear, leaving behind only 404 Error messages; and some entrepreneur will probably try to consolidate the market in the next few years.

From your perspective as a filmmaker, the technology to own and communicate with your audience, and to share and monetize your movies, will continue to improve. It won't necessarily get less expensive—even though some opportunities may cost pennies in cash terms, they will be balanced with the need for enormous resources of time and people-power to make them effective. In the end, you'll get what you pay for.

Yet, easy or difficult, cheap or exorbitant, the potential to own your rights and make money from them is here to stay. As a filmmaker, you'll begin planning your Free Range Distribution strategy from the moment you begin planning your movie, and you'll use Free Range opportunities either as an ancillary marketplace if you get a traditional distribution deal, or as your primary revenue stream if that best suits your film. You've made it to the 99th Inside Track tip, so you're probably doing this one already!

ESSENTIAL **RESOURCES**

DISTRIBUTION PLATFORMS **WHERE YOU SELL OR LICENSE YOUR RIGHTS**

Please note: The names and companies in this roster, and those that follow it, don't imply my endorsement. You have to check them out yourself and determine what will be the best fit for your project. In addition, because the media industry changes so frequently, some of these companies will go out of business, new ones will emerge, and many of them will change their terms and policies frequently. Please do your own research.

AMPLIFY (http://amplifyreleasing.com/) is a new independent distribution company that formed after Variance Films and GoDigital merged in 2014. The company distributes seven to ten films a year across major platforms. They work with filmmakers to identify the best platform for release.

How to submit: Amplify requires you to email all pertinent information about your film. For more information: http://amplifyreleasing.com/about/.

CINEDIGM (www.cinedigm.com) is an art house distributor that provides clients with exhibition software, marketing support, and distribution platform for independent films.

How to submit: Fill out the contact form to receive further details; information can be submitted here: http://www.cinedigm.com/about-us/contact/.

CREATESPACE (https://www.createspace.com/) isn't just for books; you can use it to distribute your videos through Internet retail outlets, your own website, and other retailers.

How to submit: Provide artwork by uploading the cover image you want to appear in the Amazon Instant Video listing through your account. It should not look like a product shot of a physical DVD and cannot include a DVD logo. Must be sized as a 1200 x 1600-pixel JPEG.

DOGWOOF (www.dogwoof.com) distributes social issue and documentary feature films. Dogwoof helps filmmakers promote and sell their film rights globally through its network of international distributors and broadcasters. It also guarantees a U.K. distribution deal.

How to submit: Complete the online submission form here: http://dogwoof.com/about/submissions/.

FILM BUFF (www.filmbuff.com) is a film distributor for feature films that distributes across traditional models as well as VOD (video on demand). It offers a variety of tools for filmmakers to use to increase the overall performance of their films.

How to Submit: Film Buff has an online submission form; information here: http://submissions.filmbuff.com/.

GRAVITAS VENTURES (www.gravitasventures.com) is an aggregator, connecting independent filmmakers, producers, and distribution companies to leading cable, satellite, telco, and online distribution partners.

How to submit: Gravitas Ventures has an online submission form: http://www.gravitasventures.com/contact/. You must also send two DVD screeners to the address given, with full contact information. The following information must be included: cast (in billing order), director, genre, running time, website, a short synopsis (185 characters, including spaces), a long synopsis (944 characters, including spaces). The screeners will not be returned.

ITUNES (www.apple.com/itunes) accepts feature-length motion pictures or documentaries that were initially released either in theaters or directly to video, as well as short films of theatrical or DVD quality.

How to submit: The majority of independent movies offered on iTunes are provided by one of its aggregator partners. The cost of partnership with an aggregator varies, but it is usually around $1,500. A list of Apple-approved aggregators can be found here: https://itunesconnect.apple.com/WebObjects/iTunesConnect.woa/wa/displayAggregators?ccTypeId=7. The application to work directly with iTunes and more information can be found here: https://itunesconnect.apple.com/WebObjects/iTunesConnect.woa/wa/apply.

THE ORCHARD (http://www.theorchard.com/) has distribution offices in North America, South America, Australia, Africa, Asia, and Europe. It offers its clients a variety of services from marketing advice, to an online tool dashboard filmmakers can use in order to increase their film's performance in the marketplace.

How to Submit: Fill out the online form found here: http://www.theorchard.com/contact-us/. The company will contact you with the best options for your film and tell you if/where it can be distributed.

FREE RANGE **DISTRIBUTION PLATFORMS**

With Free Range Distribution, you get to keep all your rights and can use any of these platforms to help you reach your audience.

BREAKTHROUGH DISTRIBUTION(www.breakthroughdistribution. wordpress.com) offers several retail distribution options that enable you to maintain rights so you can also self-distribute your film, such as limited retail distribution and non-exclusive retail distribution.

How to submit: Breakthrough requires that you call its office or request information. For more information: http://breakthroughdistribution.wordpress.com/faqs/.

BRIGHTCOVE (www.brightcove.com) is an online video hosting platform offering a range of products used to publish and distribute films.

How to submit: For contact information: http://go.brightcove.com/forms/contact-sales/.

CINECLIQ PRO (www.pro.cinecliq.com) provides an interface to stream your film for free on Facebook. Cinecliq Pro connects with a global audience via its proprietary Facebook-integrated distribution platform and creates customized solutions for rights holders. It targets audiences based on their interests to connect them to relevant content.

How to submit: Contact for further information: http://pro.cinecliq.com/contacts/.

CREATESPACE (www.createspace.com) is an Amazon company that helps independent filmmakers distribute their films either by sale of DVDs or through Amazon Instant Video.

How to submit: For complete information on submissions and pricing: https://www.createspace.com/Products/ DVD/ or https://www.createspace.com/Products/VideoDownload/.

DISTRIBBER (www.distribber.com) delivers content to a variety of platforms for cable providers, streaming companies, and retail stores. There are initial setup fees for each content provider as well as different revenue sharing breakdowns. Please consult its website for the most current information for costs and revenue.

How to submit: Joining and submission are free; for more information: http://www.distribber.com/howitworks.

DISTRIFY (www.distrify.com) offers a variety of analytical tools to maximize distribution of a film in the online marketplace. It offers a variety of membership plans that meet different levels of distribution needs for filmmakers.

How to submit: To sign up and get further information about plans: http://distrify.com/plan.

E-JUNKIE (www.e-junkie.com) enables buyers to purchase via PayPal or by credit card. You can use E-Junkie to sell your film in the form of a download or a DVD from your own website. The pricing is determined by the number of products being sold and the file size of the download.

How to submit: Register here: https://www.e-junkie. com/ej/register.php.

FANDOR (http://www.fandor.com/) is a highly curated independent movie subscription website and community that also offers a variety of social sharing services. Fandor is actively experimenting with new models for connecting filmmakers and audiences, and it provides a robust suite of services. It splits revenues 50/50 with the filmmaker.

How to submit: Screeners can be sent to Fandor's headquarters; information here: http://www.fandor.com/company/film_submission.

INDIEBLITZ (www.indieblitz.com) is a boutique distribution company that offers filmmakers full support with the distribution and delivery of their film across all platforms. It provides filmmakers with detailed reports, monthly payments, and customer service to aid filmmakers at every step of the distribution process. It provides different membership plans to clients to meet different needs.

How to submit: To sign up: http://indieblitz.com/pricing/.

INDIEFLIX (www.indieflix.com) curates quality independent films from festivals all over the world. IndieFlix allows independent filmmakers to non-exclusively sell their films while maintaining their rights. It aims to bridge the gap between film festival favorites and distribution. In order to apply, a filmmaker's film must have screened at a film festival; however, the company sometimes makes an exception to this rule.

How to submit: IndieFlix has a two-part process of submission and acceptance; information found here: https://indieflix.com/filmmakers.

INDIEPIX (www.indiepixfilms.com) provides avenues

for distribution, including IndiePix Films' Download-to-Own technology as well as DVD delivery by mail. It maintains an open submission policy and accepts films from all countries with no restrictions on length, genre, or subject matter.

How to submit: By mail: http://www.indiepixfilms.com/info/submit.

INDIEREIGN (www.indiereign.com) enables you to control and monetize the distribution of your films online. It has offices in the United States, India, and New Zealand.

How to submit: Create a free account: http://www.indiereign.com/sellvideos.

PIVOTSHARE (www.pivotshare.com) is a company that helps filmmakers sell directly to their audience using pay-per-view rentals, purchased downloads, and channel-wide subscription. It's free to start a Pivotshare channel. Filmmakers can customize their marketing on every level to increase brand recognition and boost interaction with their audience.

How to submit: To sign up: https://www.pivotshare.com/signup/.

QUIVER (http://quiverdigital.com/offerings/) provides aggregation and distribution capabilities for content to popular digital retail platforms like iTunes, Amazon, and Google Play. Clients only need to submit their film once for it to appear in all these platforms. You pay a flat service fee and keep all your rights and all your revenue.

How to submit: You can send files by following the guided upload process found here: http://quiverdigital.com/offerings/. You can also send your materials as physical materials, if preferred, on any standard hard drive,

flash disk, HDCAM, HDCAM SR, DigiBeta, DigiBeta SP, or D5 tape.

REELHOUSE (www.reelhouse.org) is an online video community that supports self-distributing filmmakers. It offers online tools for monetization, social sharing, and showcasing that allow filmmakers to directly reach their audience in more meaningful ways.

How to submit: Information on how to get started with Reelhouse: https://www.reelhouse.org/get-started.

SNAGFILMS (www.snagfilms.com) is a digital platform owned and created by Indiewire that promotes free access to high-quality entertainment, and also offers support distribution to documentaries and indie narrative films. Snag-Films combines its own professional opinions with those of the public as a part of the curating process. It distributes its collection across a variety of platforms.

How to submit: SnagFilms prefers online entries submitted via withoutabox.com; information here: http://www.snagfilms.com/films/submissions.

TUGG (www.Tugg.com) is a company that helps filmmakers book theaters for screenings. It is a simple process of creating an event and using social networks to gain support; then, when enough people commit, Tugg will book the venue.

How to submit: Email: films@tugginc.com.

VHX (www.vhx.tv) supports filmmakers who sell content directly from their own website to customers. It provides help in design, social media integration, SEO optimization, and analytics tools.

How to submit: Sign up here: https://www.vhx.tv/signup.

YEKRA (www.yekra.com/corp) is a direct-to-audience marketing and distribution company that helps independent filmmakers and studios target an audience for a film. It offers a variety of tools to help foster strong audience support for a film and increase sales in the theater and digital marketplace.

How to submit: Fill out the online submission form: https://yekra.wufoo.com/forms/use-yekra-to-distribute-your-film/.

DIRECTORY **OF SALES AGENTS**

If your film has genuine commercial potential in the United States and other countries, you will need a sales company to represent you and negotiate your deals. Here is a list of the most established sales companies.

Some of their websites have submission information; for the others, send them a brief email requesting their submissions procedure. Do your homework! Some sales companies specialize in specific genres, movies for certain markets (or countries), films directed by well-known directors, and so on. Only target sales companies that have a track record of representing films such as yours.

Once you have your target list, make sure to keep these sales companies in your creative loop—let them know when you start shooting, when you finish shooting, and what festivals have accepted you, and don't forget to invite them to screenings or festival engagements.

13 FILMS
8840 Wilshire Blvd., 2nd Flr.
Beverly Hills, CA 90211, USA
Tel: 310-358-3026
www.13films.net
mail@13films.net

2929 INTERNATIONAL
www.2929entertainment.com

ALFRED HABER DISTRIBUTION, INC.
111 Grand Ave., #203
Palisades Park, NJ 07650, USA
Tel: 201-224-8000
www.alfredhaber.com
info@haberinc.com

ALTITUDE FILM SALES
Altitude Film Entertainment
34 Fouberts Pl.
London, W1F 7PX, UK
Tel: 44 20 7478 7612
www.altitudefilment.com
info@altitudefilment.com

AMERICAN CINEMA INTERNATIONAL INC.
15363 Victory Blvd.
Van Nuys, CA 91406, USA
www.aci-americancinema.com
george@aci-americancinema.com

AMERICAN WORLD PICTURES
21700 Oxnard St., Suite 1770
Woodland Hills, CA 91367, USA
Tel: 818-340-9004
www.americanworldpictures.com

ARCHSTONE DISTRIBUTION, LLC
1201 W. 5th St., Suite T-420, 4th Flr.
Los Angeles, CA 90017, USA
Tel: 310-622-8773
www.archstonedistribution.com

ARCLIGHT FILMS, DARCLIGHT FILMS & EASTERNLIGHT
Suite 228 (FSA #40)
Building 61
Fox Studios Australia
Driver Ave.
Moore Park NSW 2021, Australia
Tel: 61 2 8353 2440
www.arclightfilms.com
info@arclightfilms.com

ARTIST VIEW ENTERTAINMENT, INC.
7141 Valjean Ave., Suite 200
Los Angeles, CA 91406, USA
Tel: 818-752-2480
www.artistviewent.com
scott@artistviewent.com

AV PICTURES LIMITED
Caparo House, 103 Baker St.
London, W1U 6LN, UK
Tel: 44 207 317 0140
www.avpictures.co.uk

BANKSIDE FILMS
Douglas House
3 Richmond Buildings, 4th Flr.
London, W1D 3HE, UK
Tel: 44 20 7734 3566
www.bankside-films.com

BLUE GALAXY INTERNATIONAL, LLC
13412 Ventura Blvd.
Sherman Oaks, CA 91423, USA

Tel: 818-907-7226
www.bluegalaxyinternational.com
marcy.rubin@bluegalaxyinternational.com

CELSIUS
29 Brook Mews N.
Hyde Park, London, W2 3BW, UK
in@celsiusentertainment.com
http://alllouisianafilmstudios.com/CELSIUS/

CMG—CINEMA MANAGEMENT GROUP
8730 Wilshire Blvd., Suite 416
Beverly Hills, CA 90211, USA
Tel: 310-300-9959
www.cinemamanagementgroup.com

CINEMAVAULT
1240 Bay St., Suite 307
Toronto, M5R 2A7
Canada
Tel: 416-363-6060
www.cinemavault.com

CONTENT MEDIA CORPORATION
225 Arizona Ave., Suite 250
Santa Monica, CA 90401, USA
Tel: 310-576-1059
www.contentmediacorp.com
Head Office:
Content Media Group
19 Heddon St.
London, W1B 4BG, UK
Tel: 44 20 7851 6500

CRYSTAL SKY LLC
1901 Avenue of the Stars, Suite 605
Los Angeles, CA 90067, USA
Tel: 310-843-0223
www.crystalsky.com
info@crystal-sky.com

CURB ENTERTAINMENT INTERNATIONAL CORPORATION
3907 W. Alameda Ave.
Burbank, CA 91505, USA
Tel: 818-843-8580
www.curbentertainment.com

DISTANT HORIZON
1519 Bainum Dr.
Los Angeles, CA 90290, USA
www.distant-horizon.com
london@distant-horizon.com

EALING STUDIOS INTL
Ealing Green
London, W5 5EP, UK
Tel: 44 208 567 6655
www.ealingstudios.com

ECHO BRIDGE ENTERTAINMENT LLC
75 Second Ave., Suite 500
Needham, MA 02494, USA
Tel: 781-444-6767
www.echobridgeentertainment.com
info@ebellc.com

ELECTRIC CITY ENTERTAINMENT LLC
8409 Santa Monica Blvd.
West Hollywood, CA 90069, USA
Tel: 323-654-7800
www.electric-entertainment.com

ELEPHANT EYE FILMS
27 W. 20th St., Suite 607
New York, NY 10011, USA
Tel: 212-488-8877
www.elephanteyefilms.com

ELLE DRIVER
66 rue Miromesnil
75008 Paris, France
Tel: 33 1 56 43 48 76
http://www.elledriver.fr/

EMBANKMENT FILMS LIMITED
242 Acklam Rd.
London, W10 5JJ, UK
Tel: 44 207 183 4739
www.embankmentfilms.com
info@embankmentfilms.com

ENTERTAINME US, LLC
Sunset Tower, Penthouse
6430 Sunset Blvd., Suite 1550
Hollywood, CA 90028, USA
Tel: 323-785-6900
www.entertainmeus.com
info@entertainmeus.com

ENTERTAINMENT ONE FILMS (EONE)
175 Bloor St. E.
Suite 1400, North Tower
Toronto, ON M4W 3R8, Canada
Tel: 416-646-2400
www.eonefilms.com

EPIC PICTURES GROUP, INC.
6725 Sunset Blvd., Suite 330
Hollywood, CA 90028, USA
Tel: 323-207-4170
www.epic-pictures.com
sales@epic-pictures.com

THE EXCHANGE INC.
5670 Wilshire Blvd., Suite 2540
Los Angeles, CA 90036, USA
Tel: 310-935-3760
info@theexchange.ws
http://www.theexchange.ws/

EXCLUSIVE MEDIA
9100 Wilshire Blvd., Suite 401 East
Beverly Hills, CA 90212, USA
Tel: 310-300-9000

52 HAYMARKET
London, SW1Y 4RP, UK
Tel: 44 203 002 9510

FABRICATION FILMS
6711 Forest Lawn Dr., #106
Los Angeles, CA 90068, USA

Tel: 323-874-2655 ext. 205
Fax: 323-874-2654
www.fabricationfilms.com

FANDANGO PORTOBELLO
12 Addison Ave.
London, W11 4QR, UK
Tel: 44 207 605 1396
sales@fandangoportobello.com
http://www.portobellopictures.com/Fandango-Portobello

FILMBOX
460 Greenwich St., 3rd Flr.
New York, NY 10013, USA
Tel: 212-625-0266

FILMNATION ENTERTAINMENT
150 W. 22nd St., 9th Flr.
New York, NY 10011, USA
Tel: 917-484-8900
info@wearefilmnation.com
www.wearefilmnation.com

THE FILM SALES COMPANY
165 Madison Ave., Suite 601
New York, NY 10016, USA
Tel: 212-481-5020
www.filmsalescorp.com

FILMS BOUTIQUE
Skalitzer Str. 54A
10997 Berlin, Germany
Tel: 49 30 69 53 78 50
www.filmsboutique.com

FILMS DISTRIBUTION
34 rue du Louvre
75001 Paris, France
Tel: 33 1 53 10 33 99
http://www.filmsdistribution.com/accueil.php
info@filmsdistribution.com

FLIXHOUSE GLOBAL LLC
9018 Balboa Blvd., Suite 527
Northridge, CA 91325, USA
www.flixhouseglobal.com

FORTISSIMO FILMS
Van Diemenstraat 100
Amsterdam 1013 CN, The Netherlands
Tel: 31 20 627 32 15
www.fortissimofilms.com

GALLOPING FILMS
9 Atthow Ave., Ashgrove
Brisbane QLD 4060, Australia
Tel: 011 617 3040 2664
www.gallopingfilms.com
carlos@gallopingfilms.com

GARDEN THIEVES PICTURES
700 12th St. NW, Suite 700
Washington, DC 20005, USA
www.gardenthieves.com

GAUMONT
30 ave Charles de Gaulle
92200 Neuilly Sur Seine, France

Tel: 33 1 46 43 21 80
www.gaumont.net

GFM FILMS
10 Coda Centre
189 Munster Rd.
London, SW6 6AW, UK
Tel: 44 207 186 6300
www.gfmfilms.co.uk

GK FILMS
1221 2nd St., Suite 200
Santa Monica, CA 90401, USA
Tel: 310-315-1722
www.gk-films.com
contact@gk-films.com

GLOBAL SCREEN
Sonnenstraße 21
80331 Munich, Germany
Tel: 49 89 244 1295 500
www.globalscreen.de
info@globalscreen.de

GOALPOST FILM
54 Lynette Ave.
Clapham South
London, SW4 9HD, UK
Tel: 44 207 585 3232
www.goalpostfilm.com

GOLDCREST
65-66 Dean St.

London, W1D 4PL, UK
Tel: 44 207 437 8696
www.goldcrestfilms.com

GOLD LION FILMS
www.goldlionfilms.com
cm@goldlionfilms.com

HANWAY
24 Hanway St.
London, W1T 1UH, UK
Tel: 44 207 290 0750
www.hanwayfilms.com

HARMONY GOLD U.S.A., INC.
7655 Sunset Blvd.
Los Angeles, CA 90046, USA
www.harmonygold.com
sales@harmonygold.com

HIGHLAND FILM GROUP LLC
9200 Sunset Blvd., Suite 600
West Hollywood, CA 90069, USA
Tel: 310-271-8400
www.highlandfilmgroup.com
sales@highlandfilmgroup.com

HIGH POINT MEDIA GROUP
Suite 16, Deane House Studios
27 Greenwood Pl.
London, NW5 1LB, UK
Tel: 44 20 7424 6870
www.highpointfilms.co.uk

HOUSE OF FILM LLC
427 N. Canon Dr.
Beverly Hills, CA 90210, USA
Tel: 310-777-0237
www.houseoffilm.com

H2O MOTION PICTURES
23 Denmark St., 3rd Flr.
London, WC2H 8NH, UK
Tel: 44 207 240 5656
www.h2omotionpictures.com

HYDE PARK INTERNATIONAL
3500 W. Olive Ave., Suite 300
Burbank, CA 91505, USA
www.hydeparkentertainment.com
accounting@hydeparkentertainment.com

IFM WORLD RELEASING
1328 E. Palmer Ave.
Glendale, CA 91205, USA
Tel: 818-243-4976
www.ifmfilm.com
contact@ifmfilm.com

IMAGEWORKS ENTERTAINMENT INTERNATIONAL, INC.
21910 Plummer St.
Chatsworth, CA 91311, USA
Tel: 818-349-5777
www.imageworksentertainment.com
info@imageworksentertainment.com

IMAGINATION WORLDWIDE
9107 Wilshire Blvd., #625
Beverly Hills, CA 90210, USA
Tel: 310-888-3494
www.imagination-llc.com

IM GLOBAL
Los Angeles Beverly Quest Building
8201 Beverly Blvd., 5th Flr.
Los Angeles, CA 90048, USA
Tel: 310-777-3590
www.imglobalfilm.com
info@imglobalfilm.com

INDEPENDENT
32 Tavistock St.
London, WC2E 7PB, UK
Tel: 44 207 257 8734
www.independentfilmcompany.com

INFERNO ENTERTAINMENT
1888 Century Park E., Suite 1548
Los Angeles, CA 90067, USA
Tel: 310-598-2550
www.inferno-entertainment.com

INSTINCT ENTERTAINMENT
111 Nott St.
Port Melbourne VIC 3207, Australia
Tel: 61 3 9646 0955
www.instinctentertainment.com

INTANDEM FILMS
114-116 Charing Cross Rd.
London, WC2H 0JR, UK
Tel: 44 20 7851 3800
www.intandemfilms.com
info@intandemfilms.com

ITN DISTRIBUTION
9663 Santa Monica Blvd., #859
Beverly Hills, CA 90210, USA
Tel: 702-882-6926
www.itndistribution.com

KATHY MORGAN INTERNATIONAL (KMI)
12250 Sky Ln.
Los Angeles, CA 90049, USA
Tel: 310-472-6300
www.kmifilms.com
kathy@kmifilms.com

K5
Konradinstr. 5
81543 Munich, Germany
Tel: 49 89 375 055 910
info@k5international.com
www.k5international.com

KIMMEL INTERNATIONAL
9460 Wilshire Blvd., 5th Flr.
Beverly Hills, CA 90212, USA
Tel: 310-777-8818
www.kimmelinternational.com
reception@skefilms.com

KOAN INC.
PO Box 982557
Park City, UT 84098, USA
Tel: 435-645-7244
www.koaninc.com
sales@koaninc.com

LAKESHORE ENTERTAINMENT GROUP, LLC
9268 W. 3rd St.
Beverly Hills, CA 90210, USA
Tel: 310-867-8000
www.lakeshoreentertainment.com
info@lakeshoreentertainment.com

LEFT FILM SALES
Saint Line House
Mount Stuart Square
Cardiff, CF105KR, UK
Tel: 44 780 229 9182
www.leftfilms.com

LEVELK
Gl. Kongvej 137B, 3rd Flr.
1850 Frederiksberg C, Denmark
Tel: 45 4844 3072
www.levelk.dk
tine.klint@levelk.dk

LIGHTNING ENTERTAINMENT
301 Arizona Ave., 4th Flr.
Santa Monica, CA 90401, USA
Tel: 323-852-5020
www.lightning-ent.com

LIONSGATE
2700 Colorado Ave., #2004
Santa Monica, CA 90404, USA
Tel: 310-449-9200
www.lionsgate.com
general-inquiries@lionsgate.com

THE LITTLE FILM COMPANY
12930 Ventura Blvd.
Suite 822
Studio City, CA 91604, USA
Tel: 818-762-6999
www.thelittlefilmcompany.com

MAR VISTA ENTERTAINMENT, LLC
10277 W. Olympic Blvd.
Los Angeles, CA 90067, USA
Tel: 310-737-0950
www.marvista.net

THE MATCH FACTORY
Balthasarstrasse 79-81
50670 Cologne, Germany
Tel: 49 22 15 39 70 90
www.the-match-factory.com
info@matchfactory.de

MEDIA 8
3305 SW 1st Ave.
Miami, FL 33145, USA
Tel: 786-623-5480
www.media8entertainment.com
info@media8ent.com

MEDIA LUNA NEW FILMS
Aachener Strasse 24
50674 Cologne, Germany
Tel: 49 22 15 10 91 891
www.medialuna.biz

MEMENTO FILMS INTL
9 Cité Paradis
75010 Paris, France
Tel: 33 1 53 34 90 20
www.memento-films.com

MERIDIANA FILMS
20 Arthur Rd.
London, N7 6DR, UK
Tel: 44 207 700 3088
www.meridianafilms.com
helen@meridianafilms.com

METRO INTERNATIONAL ENTERTAINMENT
16 Lincoln's Inn Fields
Holborn, London, WC2A 3ED, UK
Tel: 44 20 7396 5301
www.metro-films.com
sales@metro-films.com

MISSION PICTURES INTERNATIONAL, LLC
4400 Coldwater Canyon Ave., Suite 315
Studio City, CA 91604, USA
Tel: 310-576-7555
www.missionpicturesintl.com

MISTER SMITH ENTERTAINMENT LIMITED
77 Dean St.
London, W1D 3SH, UK
Tel: 44 20 7494 1724
www.mistersmithent.com

MONTECRISTO INTERNATIONAL ENTERTAINMENT LLC
7529 Franklin Ave.
Los Angeles, CA 90046, USA
Tel: 917-647-7587
www.montecristoentertainment.com
sales@montecristoentertainment.com

MOONSTONE ENTERTAINMENT, INC.
3539 Laurel Canyon Blvd.
Studio City, CA 91604, USA
Tel: 818-985-3003
www.moonstonefilms.com

MORGAN CREEK INTERNATIONAL, INC.
10351 Santa Monica Blvd.
Los Angeles, CA 90025, USA
Tel: 310-432-4848
www.morgancreek.com

MOTION PICTURE CORPORATION OF AMERICA
Santa Monica Blvd., Suite 180
Los Angeles, CA, 90025, USA
Tel: 310-319-9500
www.mpcafilm.com
info@mpcafilm.com

MOVIEHOUSE ENTERTAINMENT
11 Denmark St., 4th Flr.
London, WC2H 8LS, UK
Tel: 44 207 836 5536
www.moviehouseent.com

MULTIVISIONNAIRE
3080 W. Valley Blvd., Suite B
Alhambra, CA 91803, USA
Tel: 626-284-0344
www.multivisionnaire.com
distribution@multivisionnaire.com

MYRIAD PICTURES
3015 Main St., Suite 400
Santa Monica, CA 90405, USA
Tel: 310-279-4000
info@myriadpictures.com
www.myriadpictures.com

NEW FILMS INTERNATIONAL
14320 Ventura Blvd., #619
Sherman Oaks, CA 91423, USA
Tel: 818-501-2720
www.newfilmsint.com
info@newfilmsint.com

NEW HORIZONS PICTURE CORP.
customerservice@newhorizonspictures.com
www.newhorizonspictures.com

NEW LINE CINEMA INTERNATIONAL RELEASING, INC.
www.newline.com

NEW ZEALAND FILM COMMISSION
PO Box 11 546
Manners St.
Wellington 6142, New Zealand
www.nzfilm.co.nz
mail@nzfilm.co.nz

NORDISK FILM A/S
Mosedalvej 14
2500 Valby
Denmark
Tel: +45 36 18 82 00
www.nordiskfilmsales.com
contact@nordiskfilm.com

NU IMAGE / MILLENNIUM FILMS
6423 Wilshire Blvd.
Los Angeles, CA 90048, USA
Tel: 310-388-6900
www.nuimage.net
sales@nuimage.net

ODIN'S EYE
FSA 24 Fox Studios Australia
Driver Ave.
Moore Park, NSW 2021, Australia
Tel: 61 4 0391 4317
www.odinseyeent.com
info@odinseyeent.com

OPUS DISTRIBUTION
4132 Greenbrier Ln.
Tarzana, CA 91356, USA
Tel: 818-708-8278
www.opusdistribution.com
kdubow@opusdistribution.com

PANORAMA MEDIA, LLC
9536 Wilshire Blvd., Suite 206
Beverly Hills, CA 90212, USA
Tel: 310-858-1001
www.filmpanorama.com

PARAMOUNT
5555 Melrose Ave.
Hollywood, CA 90038, USA
Tel: 323-956-8398
www.paramount.com/

PARK ENTERTAINMENT
54 Broadwick St.
London, W1F 7AH, UK
Tel: 44 207 434 4176
www.parkentertainment.com

PARKLAND PICTURES
Riverbank House
1 Putney Bridge Approach
London, SW6 3JD, UK
Tel: 44 207 099 9212
www.parklandpictures.com
info@parklandpictures.com

PARTICIPANT MEDIA
335 Maple Dr., #245
Beverly Hills, CA 90210, USA
Tel: 310-550-5100
www.participantmedia.com
info@participantproductions.com
info@participantmedia.com

PATHÉ INTERNATIONAL
2 rue Lamennais
75008 Paris, France
Tel: 33 1 71 72 33 05
www.patheinternational.com
sales@patheinternational.com

PORCHLIGHT ENTERTAINMENT
11050 Santa Monica Blvd., 3rd Flr.
Los Angeles, CA 90025, USA
Tel: 310-477-8400
www.porchlight.com

PREMIERE ENTERTAINMENT GROUP, LLC
17049 Ventura Blvd.
Encino, CA 91316, USA
Tel: 818-386-9458
www.premiereentertainmentgroup.com

PROTAGONIST PICTURES
4th Flr., Waverley House
7-12 Noel St.
London, W1F 8GQ, UK
Tel: 44 207 734 9000
www.protagonistpictures.com

PYRAMIDE
5 rue du Chevalier de Saint-George
75008 Paris, France
Tel: 33 1 42 96 01 01
www.pyramidefilms.com

QED INTERNATIONAL
1800 N. Highland Ave., 5th Flr.
Los Angeles, CA 90028, USA
Tel: 323-785-7900
www.qedintl.com
jfriedberg@qedintl.com

RADIOACTIVEGIANT
3000 Olympic Blvd.
Santa Monica, CA 90404, USA
Tel: 310-954-9353
www.radioactivegiant.com
thelist@radioactivegiant.com

REEL ONE ENTERTAINMENT, INC.
9107 Wilshire Blvd.
Beverly Hills, CA 90210, USA
Tel: 310-888-2244
http://reeloneent.com/

RELATIVITY MEDIA, LLC
9242 Beverly Blvd., Suite 300
Beverly Hills, CA 90210, USA
Tel: 310-724-7700
www.relativitymediallc.com

REZO
29 rue du Faubourg, Poissonnière
75009 Paris, France
Tel: 33 1 42 46 46 30
infosrezo@rezofilms.com
www.rezofilms.com

SALT COMPANY INTERNATIONAL
1A Adpar St., 3rd Flr.
London, W2 1DE, UK
Tel: 44 207 535 6714
www.salt-co.com
info@salt-co.com

SC FILMS INTERNATIONAL
3A Lower James St.
London, W1F 9EH, UK
Tel: 44 207 287 1900
www.scfilmsinternational.com
info@scfilmsinternational.com

SCREEN CORPORATION
4 Scarborough Pl.
Beacon Hill NSW 2100, Australia
Tel: 61 2 9452 6112
www.screencorp.com

SCREEN MEDIA
757 Third Ave., 3rd Flr.
New York, NY 10017, USA
Tel: 212-308-1790
www.screenmedia.net
info@screenmedia.net

SHORELINE ENTERTAINMENT
1875 Century Park E., Suite 600
Los Angeles, CA 90067, USA
Tel: 310-551-2060
www.shorelineentertainment.com
info@shorelineentertainment.com

SIERRA/AFFINITY
9460 Wilshire Blvd., 5th Flr.
Beverly Hills, CA 90212, USA
Tel: 310-777-4550
www.sierra-affinity.com
info@sierra-affinity.com

THE SOLUTION ENTERTAINMENT GROUP
6063 Sunset Blvd.
Hollywood, CA 90028, USA
Tel: 310-272-9002
malee@thesolutionent.com

SONAR INTERNATIONAL DISTRIBUTION, INC.
2121 Avenue of the Stars, Suite 2980
Los Angeles, CA 90067, USA
Tel: 424-230-7140
www.sonarent.com
contact@sonarent.com

SONY PICTURES ENT
10202 W. Washington Blvd.
Culver City, CA 90232, USA
www.sonypictures.com

SPOTLIGHT PICTURES, LLC
6671 Sunset Blvd., #1591
Hollywood, CA 90028, USA
Tel: 323-871-2551
www.spotlight-pictures.com
mm@spotlight-pictures.com

STARZ WORLDWIDE DISTRIBUTION
2950 N. Hollywood Way, 3rd Flr.
Burbank, CA 91505, USA
Tel: 424-204-4040
www.starzglobal.com
gene.george@starz.com

STUDIOCANAL
50 Marshall St.
London, W1F 9BQ, UK
Tel: 44 020 7534 2700
www.studiocanal.com

STUDIO CITY PICTURES, INC.
11350 Ventura Blvd., Suite 101
Studio City, CA 91604, USA
Tel: 818-505-8030

SUBMARINE ENTERTAINMENT
525 Broadway, Suite 601
New York, NY 10012, USA
Tel: 212-625-9931
www.submarine.com

TAYLOR & DODGE, LLC
6100 Wilshire Blvd., #525
Los Angeles, CA 90048, USA
Tel: 310-579-6670
www.tayloranddodge.com
info@tayloranddodge.com

TF1 INTERNATIONAL
6 place Abel Gance
92100 Boulougne Billancourt, France
Tel: 33 1 41 41 21 68
www.tf1international.com

TROMA ENTERTAINMENT, INC.
www.troma.com
http://international.tromamovies.com
international@tromamovies.com
lloydk@troma.com

UFO INTERNATIONAL
13412 Ventura Blvd., Suite 250
Sherman Oaks, CA 91423, USA
www.ufofilm.com
jeff@ufofilm.com

UMEDIA INTERNATIONAL
1331 N. Sycamore Ave., Unit 1
Hollywood, CA 90028, USA
www.umedia.eu
peter.bevan@umedia.eu

VISION FILMS, INC.
14945 Ventura Blvd., Suite 306
Sherman Oaks, CA 91403, USA
Tel: 818-784-1702
www.visionfilms.net
sales@visionfilms.net

VISIT FILMS
173 Richardson St.
Brooklyn, NY 10003, USA
Tel: 718-312-8210
www.visitfilms.com
rk@visitfilms.com

VMI WORLDWIDE
1419 Wilcox Ave.
Los Angeles, CA 90028, USA
Tel: 323-703-1115
www.visionmusicinc.net/

VOLTAGE PICTURES
116 N. Robertson Blvd., #200
Los Angeles, CA 90048, USA
Tel: 323-606-7630
www.voltagepictures.com
office@voltagepictures.com

WARNER BROS.
4000 Warner Blvd.
Burbank, CA 91522, USA
Tel: 818-954-6000
www.warnerbros.com

WEINSTEIN CO.
375 Greenwich St., 3rd Flr.
New York, NY 10013, USA
Tel: 212-941-3800
www.weinsteinco.com

WIDE MANAGEMENT
40 rue Sainte Anne
75002 Paris, France
Tel: 33 1 53 95 04 64
www.wide.management.com

WILD BUNCH
99 rue de la Verrerie
75004 Paris, France
Tel: 33 1 53 01 50 20
www.wildbunch.eu

THE WORKS INTERNATIONAL
5th Flr., Fairgate House
78 New Oxford St.
London, WC1A 1HB, UK
Tel: 44 20 7612 1080
www.theworksfilmgroup.com
www.theworksmediagroup.com/international

XYZ FILMS
4223 Glencoe Ave., Suite B119
Marina del Rey, CA 90292, USA
Tel: 310-956-1550
www.xyzfilms.com

BEST **INFORMATION SOURCES**

These websites and organizations should become part of your regular contact circle. Here you'll find information, training and networking opportunities, grant information, and, in many of them, a vast and embracing independent film community.

AMERICAN FILM MARKETING ASSOCIATION (www.afma.com) is a trade association providing the independent motion picture and television industry with marketing support services such as the American Film Market (AFM), government relations, international affairs advocacy, an arbitration program, statistical data, and information services.

ASSOCIATION OF INDEPENDENT VIDEO AND FILMMAKERS (www.aivf.org) is a national organization representing independent media artists working at all levels across all genres.

CHICKEN & EGG PICTURES (http://www.chickeneggpics.org/) is a hybrid film fund and nonprofit production company. It was created to support women filmmakers, nonfiction and fiction, emergent and veteran, who are committed to addressing the social justice, equity, and human rights issues of our times.

CINEMASHARES (www.cinemashares.com) is a social network that fully funds major motion picture projects

through fractionalized fan-based financing. It uses a patented technology that allows the potential audience to invest in a movie, observe the filmmaking process, and get a free DVD copy of the movie when it is completed.

CINEREACH (www.cinereach.org) is a not-for-profit film production company and foundation that supports filmmakers in fiction and nonfiction with grants and awards, fellowships, and other partnerships. It offers great resources and information for young filmmakers across the United States.

CINEUROPA (www.cineuropa.com) is a European portal dedicated to cinema and audiovisual media in four languages. The site contains daily news, interviews, databases, and in-depth investigations into the audiovisual industry. It's a platform where professionals can meet and exchange information and ideas.

CREATOR UP (https://creatorup.com/) is an e-learning platform that helps users learn how to make and market video content. Creator Up targets SMBs and amateurs.

FILM ANGELS (www.filmangels.org) is an angel investor organization dedicated to the financing of independent film. Filmmakers, producers, directors, and writers pitch films monthly in search of qualified investors to fund their projects. Film Angels, a Silicon Valley group, meets regularly, seeing about five pitches per month. Members are free to invest in whichever projects they choose.

Contact: team@filmangels.org.

FILMBREAK (www.filmbreak.com) is a virtual film studio that lets film fans connect with their favorite filmmakers. It offers comprehensive marketing, financing, and distribution tools for filmmakers. FilmBreak's key differentiator is its audience aggregation tool that allows filmmakers to actively build, engage, and monetize their audience. Through audience aggregation, filmmakers are able to unlock financing and distribution opportunities via FilmBreak's online marketplace.

FILM FREEWAY (https://filmfreeway.com/) provides a set of tools for filmmakers to submit their movies to festivals. Many festivals are now beginning to prefer Film Freeway. This service is free for filmmakers.

FILM INDEPENDENT (www.filmindependent.org) helps filmmakers make their movies and builds an audience for their projects. Anyone passionate about film can become a member, whether he or she is a filmmaker, industry professional, or a film lover. Film Independent provides access to a network of filmmakers. Its Artist Development program offers free labs for selected writers, directors, producers, and documentary filmmakers and presents networking opportunities. Each year, Film Independent awards a number of grants and fellowships to help filmmakers with their current projects, as well as to recognize them for past accomplishments.

FILMMAKER MAGAZINE (www.filmmakermagazine.com) is a publication providing an insider's perspective into all areas of the American independent filmmaking experience; it includes articles covering the creative process, business, and technology. The magazine is published quarterly and is

available as a benefit of IFP membership or through direct subscription, and at retail chains and newsstands internationally.

INDEPENDENT FILMMAKER PROJECT (IFP) (www.ifp.org/) is the name for a series of membership-based, not-for-profit organizations that produce programs that assist independent filmmakers in connecting with film industry professionals and audiences.

INDEPENDENT FILMMAKERS ALLIANCE (www.ifilmalliance.com) is a worldwide organization dedicated to encouraging indie filmmaking around the globe. The Alliance facilitates the exchange of information between filmmakers from around the world, serves as a resource center for filmmakers, organizes industry workshops and conferences, stimulates new projects through competitions, and engages in other such activities to move independent film production forward. The Alliance also sponsors a number of competitions for filmmakers, together with the Annual IFA Indy Film Awards, which honor the best in indie filmmaking.

INDIEVEST (www.indievest.com) is a multimedia/transmedia company that combines an exclusive member-only community with a full-service independent film studio, a domestic theatrical distributor, a global home entertainment partner (Vivendi Entertainment), and film financing (member FINRA SIPC). Its exclusive member-only community comprises high-net-worth accredited and qualified individuals, family offices, wealth managers, broker dealers, and institutions that demand open access and complete transparency while participating in the inner circle of the entertainment industry.

INDIEWIRE (www.indiewire.com) is an international news, information, and social networking site for filmmakers. The website includes coverage of indie, documentary, and foreign-language films, as well as industry news, film festival reports, filmmaker interviews, and movie reviews.

MOVIEMAKER MAGAZINE (www.moviemaker.com/) is an independent film resource on the art and business of making movies. *MovieMaker*'s content is directed at the audience as well as the artist, with a mix of interviews, distribution and financing tips, behind-the-scenes indie "war stories," and appreciations of classic Hollywood actors, directors, cinematographers, producers, screenwriters, and editors.

MOVIESCOPE MAGAZINE (www.moviescopemag.com) is a quarterly magazine that includes contributions by key industry professionals on the filmmaking process.

NO FILM SCHOOL (nofilmschool.com) is an online community where filmmakers can find the latest information on new technology, how-to-forums, and articles on hot topics within the industry.

POV FROM PBS (www.pbs.org/pov/filmmakers/) is an online community and website that offers a variety of up-to-date information for documentary filmmakers as well as independent filmmakers. It also offers great resources for new media funding, distribution, equipment, and community forums.

THE SAN FRANCISCO FILM SOCIETY/KRF Filmmaking Grants (www.sffs.org) support feature-length narrative films with themes exploring contemporary social issues. Films customarily have a connection to the Bay Area.

SAG INDIE (http://www.sagindie.org/) offers great resources for working with SAG-AFTRA. It also offers contact information for various state offices for film information.

SEED & SPARK (www.seedandspark.com) is a one-stop shop where filmmakers can crowdfund, distribute, and interact with their audience and the broader independent film community. Seed & Spark is looking for great examples of truly independent filmmaking across all genres and budget levels. The WishList is a crowdfunding tool that functions like a wedding registry. You make a list of the items you need to make your movie. The Seed & Spark WishList works because it connects your audience directly to your project. Audience members can choose how they contribute to your project and build their own story of how they helped make your movie. This personal connection with your project makes your supporters more likely to stick around to see what happens with their specific WishList item and your film.

How to use: http://www.seedandspark.com/content/how-seedspark-0.

SHOOTING PEOPLE (www.shootingpeople.org) is an international networking organization dedicated to the support and promotion of independent filmmaking. It is a network for filmmakers based out of London. It serves as a means for independent filmmakers to connect with each other by using blogs, databases, newsletters, and podcasts. Shooting People works as a low-cost yearly subscription.

WITHOUTABOX (www.withoutabox.com) offers filmmakers access to major channels for promoting and distributing their work, including screening at international film festivals,

244 \ ESSENTIAL RESOURCES

streaming on the Internet via IMDb Theaters, and selling DVDs and video-on-demand downloads via CreateSpace.

Withoutabox allows you to explore more than 5,000 film festivals, make direct submissions to 850 festivals, and keep the process organized. Withoutabox is free. Filmmakers just pay the published entry fees of the festivals they're submitting to (unless the festival doesn't charge an entry fee). Entry fees are set by the festivals, not by Withoutabox.

YOUR ATTITUDE **IS YOUR GREATEST RESOURCE**

Persistence is everything. Your most valuable asset is your mental and emotional game. Keep yourself upbeat, because you will never stop selling.

As your movie launches from one distribution window to the next, do not stop. When you get a bad review, do not stop. If someone who runs a studio or a distribution company—a "gatekeeper"—says no, do not stop.

Keep going; stay persistent. Setbacks are normal: it's just as hard to sell a movie as it is to make it.

Keep your promotional machine going from window to window. Stay on social media, and make sure your principal cast does the same. Some movies develop fans only over long periods of time, and most audiences select the movies on a platform's "most popular" list. The "most popular" list is like the *New York Times* best seller list: it's really hard to get on it, but once you're on, it's equally hard to get off.

Have fun with this, and enjoy the interactions with your audience. They're your fans; if you're lucky, they'll stay your fans for life.

Start envisioning your next movie. It'll give you something to talk about in interviews, something to dream about when the constant marketing effort feels like a slog, something to start planning as you write the script or imagine perfect locations.

It'll be easier the next time around.

THE ACADEMY AWARD SPEECH
I HOPE YOU MAKE ONE DAY

"The envelope, please. The Academy Award for Best Picture goes to . . ."

Wow, this is amazing. I never thought I'd hold one of these!

But this award isn't for me. It's for *you*. No, not you sitting in the Dolby Theatre. For *you* out there, *the audience*.

You're why we do this. This award is for *you*.

Thank you for going to the movies. You don't need to be convinced that movies are worth watching, although after the self-congratulatory remarks earlier this evening, you'd be justified in thinking that we're feeling insecure.

That we wonder about our own relevance.

I suppose we should. Fewer of you go to the movies than a decade ago. Maybe that's because we aren't making the movies you want to watch. No, I'm not talking about pandering-to-the-lowest-common-denominator, derivative-effects-laden, high-decibel drivel—despite what some of the execs in this room think. Many of you don't go see those movies anyway, at least not in numbers enough to justify their production and marketing cost.

I'm talking about making movies for the right reason, and there is only one right reason: *to give you what you go to the movies for.*

Is it only me, or do movies seem less and less relevant to our lives? Most of the time I feel anesthetized, not "mesmerized," don't you?

Thank you for being here and sitting through a lot of movies that are, frankly, crap (can I say that on ABC?).

Thanks for coming to the movies even when they are getting so stupidly expensive you have to think twice about it. Thanks for not boycotting rising ticket prices even though they seem to be going up faster than gasoline. Your average ticket now costs more than $8! And you have to pay extra for popcorn!

The people in the front rows are cringing. They're flashing that "Wrap up now!" red light at me, but goddamn it, oh, sorry, ABC, I'm only going to be up here this once.

Hey, we all know the books are cooked. Not the studio accounting books, that's another story, I mean the books on movie attendance. Every year there's a press release that the box office is just great. It isn't! The only reason the box office stays up is because of those rising ticket prices, even though fewer people are seeing movies.

I love you, audience. I want you back!

Nice, they're starting the play-off music. Is that a way to treat an Oscar winner? WELL, I CAN TALK LOUDER THAN YOU CAN PLAY.

THANK YOU FOR WATCHING MY MOVIE ANYWHERE YOU WANT TO. THANK YOU FOR WATCHING IT ON YOUR IPAD, ON YOUR MOBILE, ON YOUR TV, ON YOUR LAPTOP. I don't care—I'm just happy you've seen our work. Even though it seems harder and more complicated every day, what with making you wait longer or shorter times to see the movie on this or that device, or in this or that way, or having to join one service or another just to see it. Because I believe that the more

movies you see—and I don't care where you see them—the more movies you will want to see!

Thank you for being here, coming, and caring. Thanks for supporting our work.

Now the host's coming over to me. Hi there, did they tell you to pull me off stage? Fine, fine, let's go, I'm done. But let's not go backstage where your thugs will put me in Movie Jail. Can we walk through the house, back along the red carpet, and go out to the street and see our fans? Really. *They're the ones we need to thank.*

INDEX

GET MORE
from
AdamLeipzig.com

AdamLeipzig.com is a haven and training campus for creative people and entrepreneurs, where you will find seminars, books and downloadable materials, useful resource links, and more "inside track" learning opportunities. You can also contact Adam Leipzig directly though this site for consulting, custom workshops, and keynote speaking engagements.

Go to www.AdamLeipzig.com and sign up for Adam's mailing list now. You'll instantly get a free report, new information as it becomes available, and valuable discounts on training and information materials.